Images of Modern America

MAGIC
MOUNTAIN

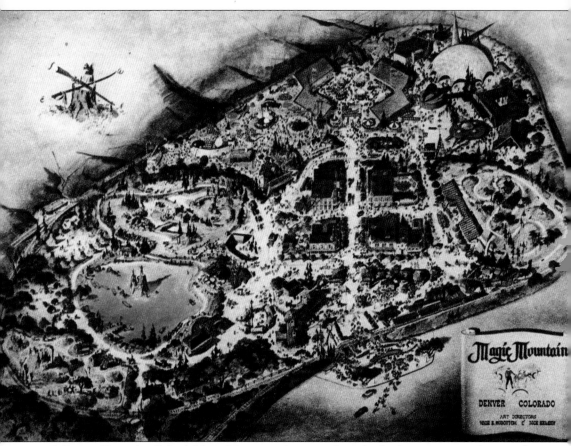

Following Disneyland's lead, Magic Mountain designers drew this bird's-eye concept plan to reflect the story line for the desired themes within the park. (Courtesy of Rick Gardner.)

Images of Modern America

MAGIC
MOUNTAIN

Robert McLaughlin

To Dana —
Welcome to the Magic!
March 7, 2023

ARCADIA
PUBLISHING

Published by Arcadia Publishing
Charleston, South Carolina

Printed in the United States of America

Library of Congress Control Number: 2015953869

For all general information, please contact Arcadia Publishing:
Telephone 843-853-2070
Fax 843-853-0044
E-mail sales@arcadiapublishing.com
For customer service and orders:
Toll-Free 1-888-313-2665

Visit us on the Internet at www.arcadiapublishing.com

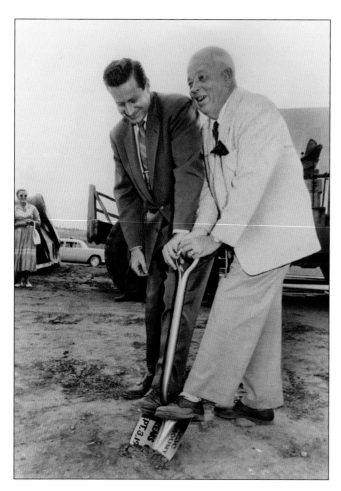

Magic Mountain is dedicated to its founder, Walter F. Cobb (right); his assistant Monty Pike; and Deputy Marshal Leroy Allen. Shown with Cobb is Lt .Gov. Frank Hays (left) at ground-breaking ceremonies held September 3, 1957. (Courtesy of the Denver Public Library, Western History Collection, Call No. 2129.)

CONTENTS

ACKNOWLEDGMENTS

After five books, it is amazing my wife, Terry, can still stand correcting this dyslexic's attempt at spelling, and my daughter Jamie typed my completely hand-printed manuscript, so I thank both of you. Tim McSherry scanned the primary images from the Allen-Pike collection, and Kris Thomas Pickett scanned the final images selected for this book, which included digital editing. Great job, Tim and Kris. A thank-you goes to the entire Arcadia team, including Stacia Bannerman, Chrissy Smith, Ryan Easterling, and director of imprints Katie Kellett. My friend and railroad historian Bill Robie gets the unsung hero award; I thank you for all your help. It was great to interview Leroy Allen and Monty Pike; we all thank you for sharing your first-hand knowledge of Magic Mountain. That also goes for their wives, Beverly and Grace. Special thanks go to Rick Gardner and Rick's aunt Sharon Gardner for access to the Cobb family collection. Rick's overall knowledge of Golden's history was a terrific source to rely on. Stephen Pike also gets a special thanks for sharing his dad, Ron's, excellent photograph collection. Thank you, Donna and Mark, for letting me use your expansive open space at your summer home to organize the image story line for all my books. Mike and Russ McGoodwin's dad, Jim, was a general manager at the park. It was fun to interview Russ who was just 17 years old when he worked as a laborer during the week and an actor on weekends. Thanks to his brother Mike for sharing a photograph of their dad. Amy Woodward gets my reporter of the year award for her February 26, 2015, story on Heritage Square for *Colorado Community Media*. This story attracted several new leads, including Norma Stevens, who, with her dad, worked at Magic Mountain and shared her family's photographs. Jerry Kannapinn and John Fisher also contributed to the story line because of Amy's story, thank you. Colorado Aerial Photo Service owner John Young supplied the beautiful aerial photographs of Magic Mountain. You and your manager Doug are great. I would like to recognize and thank the following people for their help: Coi E. Drummond-Gehrig from the Denver Public Library, Wendy Hall from the Boulder Carnegie Branch Library for local history, and Roy Johnson and Matt Isaacks from the Colorado Railroad Museum Library. Also contributing to this project are Dennis Walla, Mike Diener, Jeff Bradley, Rick Purcell, Yvonne Lashmett, Chung Park, Denver radio station KELW's Rick Crandall, Rod Pilcher, John Coker, LMG VIDS, attorney Tom Mullen, Darren Leafblad, Linda Detroy Alexander, Chip Parfet, and former Heritage Square manager Terry Raney and current manager Pete Bovis. As for our four adult children Kerry, Jamie, Tracy, and Micah, if you do not read my new book, I am changing the locks on our house.

Unless otherwise noted, all images appear courtesy of the author's collection.

INTRODUCTION

Welcome to Magic Mountain. There is going to be a historical timeline running through the next five chapters. The author's timeline started on March 24, 2000, when he purchased nine Pleasure Island postcards at a church antique show in his adopted hometown of Wakefield, Massachusetts. After having a friend enlarge the postcards, they were posted on the local town information stations along a walking path around Lake Quannapowitt. This chance encounter with nine postcards was the unofficial start of the Friends of Pleasure Island, which became a 501-C in April 2001, with a goal to document Pleasure Island's history to share with current and future generations.

During my very early research on Pleasure Island, three parks appeared besides it on our local library's microfilm machines' screen; they were Disneyland, Magic Mountain, and Freedomland. From several years of research, interviews, and site visits, *Pleasure Island* and *Freedomland* were released for the 50th anniversaries, with Pleasure Island in 2009 and Freedomland in 2010. Arcadia Publishing rolled out a new series called Images of Modern America, featuring color photographs, in January 2014. *Pleasure Island 1959–1969*, released on June 30, 2014, was the first book in this series to be released in New England. On March 2, 2015, *Freedomland 1960–1964* was released. It is my pleasure to introduce this author's third book in this exciting new series—*Magic Mountain*.

As discussed in my previous books, amusement parks have been part of America's culture for a very long time. Around the turn of the 19th century, parks with the title "trolley parks" started to appear across the American landscape. Because trolley companies paid for electricity seven days a week, they lost money on weekends when the working population was not utilizing its services. To remedy lost income, trolley companies built amusement parks so patrons would access these venues on the underserved trolley lines.

These parks offered a variety of amusements such as carousels, boat rides and boat rentals, picnic groves, band concerts, dance halls, an assortment of dining choices, and, in some of these parks, much more. One of these trolley parks was located in Kansas City, Missouri. Its name was Electric Park, and one of its guests in the 1910s was a young boy by the name of Walt Disney. Reportedly, Disney would include aspects of his early memories of Electric Park in his vision for Disneyland. Many of these trolley parks evolved into traditional amusement parks that currently operate throughout this country.

With the Great Depression and World War II in the rearview mirror, America was on a roll. Massive upgrades to this country's road infrastructure connected us from the smallest villages to the largest cities. With a bumper crop of baby boomers and measurable disposable income, the 1950s were the ideal time for a new type of family entertainment. This is where Magic Mountain's history merges with Disneyland's beginnings.

C.V. Wood, sometimes referred to as C.V. Wood Jr., Cornelius Vanderbilt Wood, or just Woody, was born in Wood County, Oklahoma, in 1920 and raised in Amarillo, Texas. By 1950, he became director of the Los Angeles division of the Stanford Research Institute. In 1953, Walt Disney

Productions commissioned the institute to create a comprehensive feasibility study to determine the location for Disneyland from a number of options. This study, by all accounts, was revolutionary for the leisure industry, where it not only looked at travel and population trends, past weather cycles, and more, but also how many guests would come and how much they would spend. This model is used for every venue imaginable, including theme parks.

Also working at the institute was Harrison "Buzz" Price, who was the study's project leader. Readers interested in economic research for the leisure industry should check out Price's book, *Walt's Revolution!: By the Numbers* (Ripley Entertainment, 2004). Wood was hired by Walt and Roy Disney as Disneyland's executive vice president and worked in that capacity organizing Disneyland's final site selection, a collective group of 17 individual parcels known as the Ball Road Subdivision. Wood was involved with many of the aspects that created this park and was its first general manager; although, it is well known that Walt would micromanage his dream park.

For reasons that would only be speculative, Wood was dismissed by the Disney brothers just months after Disneyland's opening. Let us just say, Wood's name does not appear on any Main Street windows at the Disney parks like his contemporaries who invented the theme park business. On the other hand, Harrison "Buzz" Price went on to consult for the Disney organization on projects such as the 1964–1965 New York World's Fair and was involved in selecting the sites for the Orlando and Tokyo parks.

When Disneyland opened its gates on July 17, 1955, Walt was 54, Roy was one week from 62, and C.V. Wood was only 35 years old. Wood was in the inside circle during the planning, hiring the design talent, construction, and operation of the first theme park in America. Having the playbook and a rolodex full of contacts, Wood started his own company, Marco Engineering, in Los Angeles. An advertisement in *Funstop* July 1960 describes Marco's techno-economic research as "complete market studies to gauge potential amusement and recreational needs of the community." Marco offered economic feasibility evaluation, site location and development, and operations research and analysis.

After Disneyland opened, just like McDonald's as an example, it was just a matter of time before investors, looking to follow the aforementioned trend leaders, would build their own venues. Reportedly, Marco Engineering set a goal of designing up to 20 regional Disneyland-type parks throughout North America. Meanwhile, in the early 1950s, Walter Francis Cobb, a plumbing contractor from Wheatridge, and Denver sculptor and designer John Calvin Sutton envisioned building a Mother Goose Storyland–type park. A publisher of a children's magazine, *Childlife*, by the name of William Hawkes was planning a similar family recreation center for the Boston area, also in the early 1950s.

It would only be speculative on how Cobb and C.V. Wood connected other than Cobb's favorable impression of Disneyland. Magic Mountain has the distinction of being the very first theme park to be designed and built in the entire country after Disneyland. As for Hawkes, what was going to be Childlife World became Boston's Pleasure Island after bringing Marco on board. Pleasure Island opened June 22, 1959, and Marco's third and last completely designed park, Freedomland, opened in New York City on June 19, 1960.

Magic Mountain, Pleasure Island, and Freedomland were the bridge between trendsetting Disneyland and the amusement parks we enjoy today, such as the Six Flags and Universal parks. Starting in 1954, families across America were introduced to Disneyland on Sunday evenings on ABC. Today, this would be known as an infomercial. Going to Disneyland was out of reach for most families. Thanks to three pioneers in the infancy of theme parks—Cobb, Hawkes, and New York's William Zeckendorf, millions of kids and their families got to experience their very own Disneyland-type park in Denver, Boston, and New York. Although short-lived, each park has an amazing story to tell, especially Magic Mountain.

One

HOLLYWOOD COMES TO COLORADO

With Marco Engineering on board, Magic Mountain, Inc., headed by Walter F. Cobb, selected a 386-acre site at 16000–17000 West Thirty-Second Avenue. The *Colorado Transcript* reported on June 4, 1957, about a meeting held Tuesday night, June 2, at the main dining room of the Rolling Hills Country Club (today's Applewood Country Club). The Applewood subdivision's owners' association met to organize opposition to the development. "Residents of the Applewood area in their meeting expressed the fear that Thirty-Second Avenue would become a super highway leading to the Magic Mountain entrance which would be most undesirable in a residential area." By July 11, 1957, the *Transcript* reported the project shifted to a new 600-acre site on US 40. Apparently, Magic Mountain, Inc., short circuited the opposition to its original site to stay on its projected track to open the park in 1958. Marco Engineering produced "The Economic Appraisal of Freedomland." Magic Mountain and Pleasure Island would have had a similar study. It would have included Magic Mountain's primary and secondary marketing areas. Other factors would include population, tourism, entertainment, habit patterns, weather, characteristics of the site, competitive and complementary attractions, and attendance at existing attractions, such as Denver's Lakeside and Elitch's amusement parks. With design and headquarters set up in Denver and studios in Lakewood, Marco designers created construction blueprints of renderings from the park's thematic story line, some of which were incorporated from Cobb's and Sutton's original concepts for the park's original site. Dick Kelsey and Wade B. Rubottom were Magic Mountain's lead art directors, as they were for Freedomland. Pleasure Island's art directors were Rubottom and Randall Duell. Richmond (Dick) Kelsey (1905–1987) was an art director for 12 years at the Walt Disney Studios. He contributed to such classics as *Bambi*, *Dumbo*, *Fantasia*, and *Pinocchio*. A local 1957 press release states Wade B. Rubottom (1903–1997) "was a set designer at Metro-Goldwyn-Mayer for 3 years and then became chief draftsman at Walter Wanger Productions. Rubottom was art director for Disneyland's Main Street." His name is above the Disney Gallery, Town Square—Main Street USA, Disneyland.

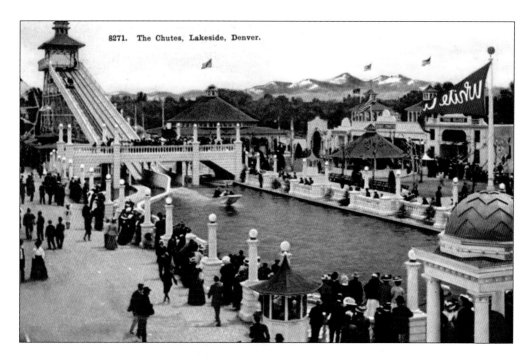

8271. The Chutes, Lakeside, Denver.

Lakeside Amusement Park has operated on the same site since 1908. It is amazing this park has survived when so many parks from this era have not. Denver-area amusement parks such as Lakeside did not go unnoticed by Magic Mountain designers looking for market share to create their recreational venue. Both images are perfect examples of attractions from traditional amusement parks that sprang up across America and beyond around the turn of the 20th century. Thankfully many of the original features from this park still survive, including reasonable pricing.

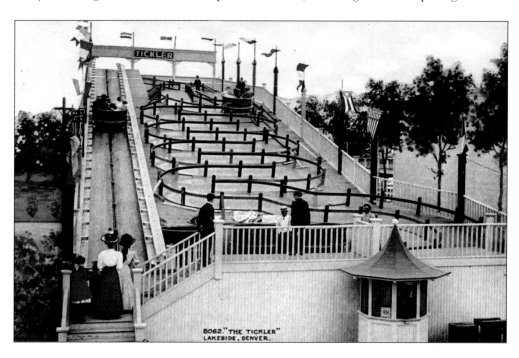

8062. "THE TICKLER"
LAKESIDE, DENVER.

Lakeside operated a large ballroom as did many of the traditional amusement parks across America throughout the big band era. This print advertisement has Jimmy Dorsey and his Orchestra booked for a six-day engagement.

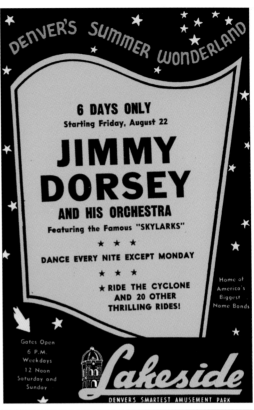

The *California Zephyr* runs the 1.25-mile circle around Lakeside's Lake Rhoda. An excerpt from this postcard states, "This all stainless-steel streamlined diesel-powered miniature train is equipped with a diesel engine, air-brakes, air-horns and air sanders just like the big streamliners."

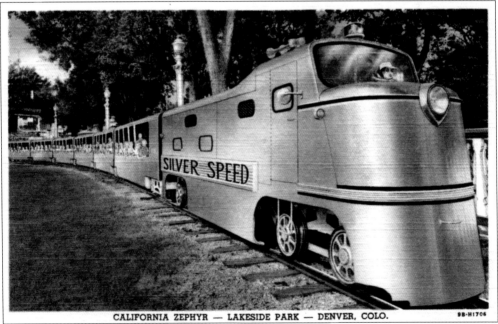

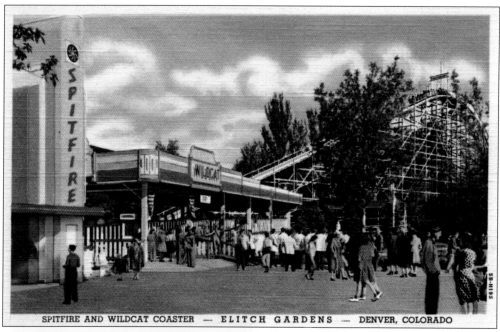

SPITFIRE AND WILDCAT COASTER — ELITCH GARDENS — DENVER, COLORADO

GREETINGS
FROM
ELITCH'S

SMILE-A-WHILE
STUDIO
ELITCH'S GARDENS
DENVER COLORADO

Denver's Elitch Gardens dates back to 1890 and was originally just a short distance from Lakeside Amusement Park. Magic Mountain, following Disneyland's original concept, would not have roller coasters or any of the traditional amusement park thrill rides, such as shown above.

Elitch Gardens operated at its original location until moving to a new site in downtown Denver, with opening day on May 27, 1995. To learn more about this park's history, Google "National Amusement Park Historical Association Lost Amusement Parks." Does anyone remember the Smile-a-While studio?

This print advertisement from 1947 is an example of the talent that performed at the Elitch Theatre and Trocadero Ballroom.

Take No. 5 Cars and No. 13 Busses to..

Elitch's

GARDENS

THRILLS

Now playing in the Summer Home of America's Biggest Bands . . . Sunday Mats. and Nightly Except Tuesday

Dick Jurgens

Tuesday Evening, August 26th, in the Troc—
DENVER POP CONCERT

GAMES

ELITCH THEATRE
Week beginning Sunday evening, August 24th
Nightly; Matinees Wed. & Sat.

"The Two Mrs. Carrolls"

NEW ORCHARD CAFE
Dinners served 5:30 to 9 p. m. daily & 2 to 9 p. m. on Sunday. Theatre mat. luncheons by reservation. GRand 7424

RIDES

Gates Open Sat. & Sun. at Noon — other days at 6 p.m. FREE Parking — Gate adm. 10c

67th Year—THE ELITCH THEATRE PROGRAM

Visit Our Beautiful
★
★ *Trocadero Court for Your*
★
★ *Favorite Drinks after the Play*
★
★
★
★
★
★
★

TROCADERO BALLROOM TROC COURT NO ADM CHG
BAND STAND

GRILL ROOM

THEATRE PATIO

OUR garden-like Trocadero Court, adjoining the ball-room, is delightfully cool and the perfect place to enjoy after-theatre refreshments. There is no admission charge to the Trocadero Court.

Opening Monday, June 16th in the "Summer Home of America's Biggest Dance Bands"

RALPH MARTERIE
and His Orchestra

Last Time Sunday, June 15, BUDDY MORROW

DANCE DURING INTERMISSION
AND AFTER THE THEATRE Special Price

Tickets sold in booth in theatre before curtain is raised and at the end of first act. Show your seat stubs to obtain this special price. Permits dancing during intermissions and after the show.

60¢ A Person

This page from the June 15 through June 21, 1958, Elitch Theatre program describes in detail a night out at Elitch Gardens. Fortunately, the theater has been saved intact at its original site, dating back to the early 1890s. To know more about what is in store for the theater, Google "The Historic Elitch Gardens Theatre Foundation."

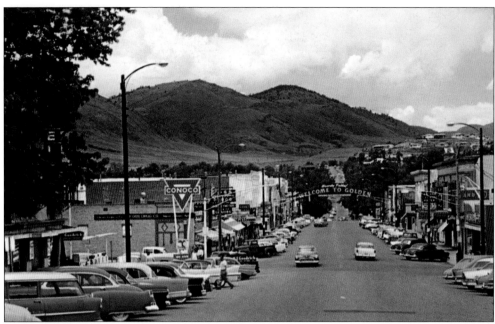

Pictured about two years after Disneyland opened in 1955 is Golden, Colorado. Golden is in for a big surprise, and the surprise is Magic Mountain.

Disneyland's opening day on July 17, 1955, set the stage for a much larger and different park than originally envisioned by Walter F. Cobb. The *Colorado Transcript* reported on May 30, 1957, "C.V. Wood (former) vice-president of Disneyland is expected to arrive in Denver on Friday to confer with corporation officials on development of the project."

Disneyland's Jungle Cruise would be reinvented by Magic Mountain designers into the River Ride attraction, also referred to as the Fur Trapper River Ride or the Forest River Ride.

Just like Disneyland's Frontierland (shown above), Magic Mountain would have two blockhouse forts plus the Burro Ride attraction. Note the happy camper with his coonskin cap. Interestingly, Fess Parker (Daniel Boone) was on hand at Boston's Pleasure Island's premier opening event June 20 and 21, 1959.

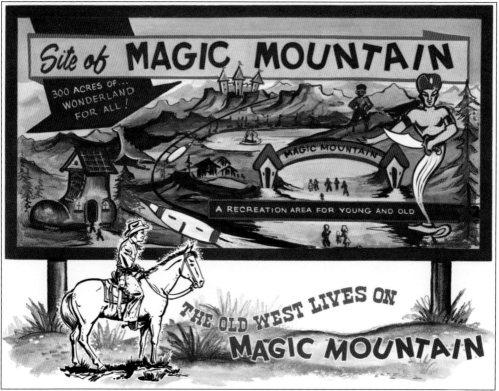

On this and the following page are four selections from Magic Mountain's prospectus for the original site off West Thirty-Second Avenue. Shown in the background is South Table Mountain. (Courtesy of Rick Gardner.)

WALTER F. COBB
President
MAGIC MOUNTAIN, Inc.

Mr. Cobb was born in Denver, Colorado, June 23, 1899. He attended schools in Denver including Regis College and St. Mary's Academy at St. Marys, Kansas. He enlisted in the U. S. Navy in 1917 and served his Country until 1919. After being Honorably discharged, he was employed by the American Telephone and Telegraph Company at Philadelphia, Pa., and Denver, Colorado.

Mr. Cobb served his apprenticeship in Denver to become both a Journeyman and a Master Plumber. In 1930 he entered into the Plumbing and Heating Contracting Business, which he has owned and operated successfully up to and including the present time.

He has had variable experience in real estate development fields, which required the "conception, foresight and judgment" to plan, construct and successfully put in operation.

Mr. Cobb resides at 12345 W. 38th Ave., Wheat Ridge, Colorado, is married and has five children and five grand children. He is a member of the American Legion, Denver Chamber of Commerce, Colorado State and National Associations of Plumbing Contractors and Wolhurst Country Club.

Most likely, John C. Sutton, Magic Mountain's vice president, created the artwork for the original site prospectus. Shown above are, from left to right, Kathy Cobb (daughter), Walter F. Cobb, Karolyn Cobb (daughter), and Lindy Cobb (granddaughter). (Courtesy of Rick Gardner.)

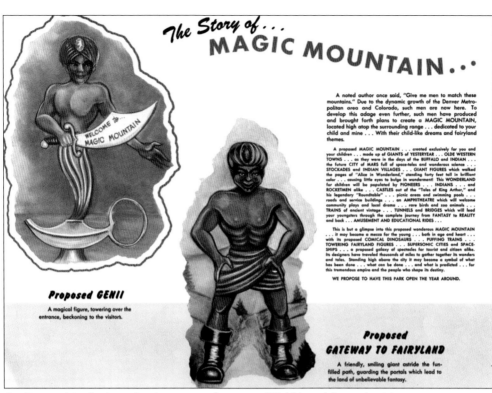

The Story of... MAGIC MOUNTAIN...

A noted author once said, "Give me men to match these mountains." Due to the dynamic growth of the Denver Metropolitan area and Colorado, such men are now here. To develop this adage even further, such men have produced and brought forth plans to create a MAGIC MOUNTAIN, located high atop the surrounding range ... dedicated to your child and mine ... With their child-like dreams and fairyland themes.

A proposed MAGIC MOUNTAIN ... created exclusively for you and your children ... made up of GIANTS of YESTERYEAR ... OLDE WESTERN TOWNS ... as they were in the days of the BUFFALO and INDIAN ... STOCKADES and INDIAN VILLAGES ... GIANT FIGURES which walked the pages of "Alice in Wonderland," standing forty feet tall in brilliant color ... causing little eyes to bulge in wonderment! This WONDERLAND for children will be populated by PIONEERS ... INDIANS ... and ROCKETMEN alike ... CASTLES out of the "Tales of King Arthur," and his legendary "Roundtable" ... picnic areas and swimming pools ... roads and service buildings ... an AMPHITHEATRE which will welcome community plays and local drama ... rare birds and zoo animals ... TRAINS of ancient vintage ... TUNNELS and BRIDGES which will lead your youngsters through the complete journey from FANTASY to REALITY and back ... AMUSEMENT AND EDUCATIONAL RIDES ...

This is but a glimpse into this proposed wonderous MAGIC MOUNTAIN ... it may become a mecca for the young ... both in age and heart ... with its proposed COMICAL DINOSAURS ... PUFFING TRAINS ... TOWERING FAIRYLAND FIGURES ... SUPERSONIC CITIES and SPACE-SHIPS ... a proposed galaxy of spectacles for tourist and citizen alike. Its designers have traveled thousands of miles to gather together its wonders and tales. Standing high above the city it may become a symbol of what has been done ... what can be done ... and what is predicted ... for this tremendous empire and the people who shape its destiny.

WE PROPOSE TO HAVE THIS PARK OPEN THE YEAR AROUND.

Proposed GENII
A magical figure, towering over the entrance, beckoning to the visitors.

Proposed GATEWAY TO FAIRYLAND
A friendly, smiling giant astride the fun-filled path, guarding the portals which lead to the land of unbelievable fantasy.

As discussed in the introduction, many elements of Cobb's and Sutton's vision were woven into Marco Engineering's designs for the park's final location. On May 30, 1957, the same day the *Colorado Transcript* story came out, Cervi's *Rocky Mountain Journal* reported a Western Disneyland to be located off West Thirty-Second Avenue. Both of these articles were the first printed mention of a Western Disneyland to be located off West Thirty-Second Avenue. Cervi's *Journal*'s lead title was "Magic Mountain Stock on Sale to Coloradoans." (Both, courtesy of Rick Gardner.)

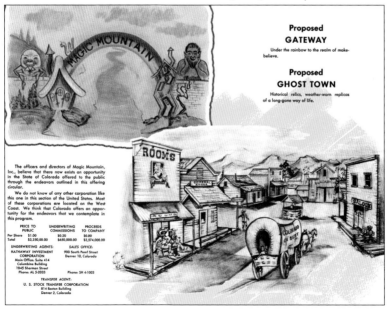

Proposed GATEWAY
Under the rainbow to the realm of make-believe.

Proposed GHOST TOWN
Historical relics, weather-worn replicas of a long-gone way of life.

The officers and directors of Magic Mountain, Inc., believe that there now exists an opportunity in the State of Colorado offered to the public through the endeavors outlined in this offering circular.

We do not know of any other corporation like this one in this section of the United States. Most of these corporations are located on the West Coast. We think that Colorado offers an opportunity for the endeavors that we contemplate in this program.

	PRICE TO PUBLIC	UNDERWRITING COMMISSIONS	PROCEEDS TO COMPANY
Per Share	$1.00	$0.20	$0.80
Total	$3,250,000.00	$650,000.00	$2,574,000.00

UNDERWRITING AGENTS:
HATHAWAY INVESTMENT CORPORATION
Main Office: Suite 414
Columbine Building
1845 Sherman Street
Phone: AL 5-2033

SALES OFFICE:
900 South Pearl Street
Denver 10, Colorado

Phone: SH 4-1003

TRANSFER AGENT:
U. S. STOCK TRANSFER CORPORATION
814 Boston Building
Denver 2, Colorado

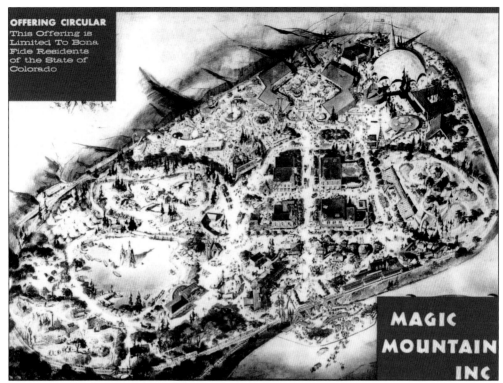

MAGIC
MOUNTAIN
INC

As discussed in the introduction, Magic Mountain shifted west to a 600-acre site outside of Golden. This area was incorporated into Golden's city limits in 1959. With the new location came a new prospectus for salesmen offering Magic Mountain's stock. The rendering and sample page from this prospectus reflects Marco Engineering's influence on the first stand-alone theme park in the United States after Disneyland. (Both, courtesy of Mike Diener.)

MAGIC MOUNTAIN

The officers and directors of Magic Mountain, Inc., believe that there now exists an opportunity in the State of Colorado offered to the Public through the endeavors outlined in this offering circular.

We do not know of any other corporation like this one in this section of the United States. Most of these corporations are located on the West Coast. We think that Colorado offers an opportunity for the endeavors that we contemplate in this program.

Construction is underway 12 miles west of Denver on U. S. Highway 40 on Magic Mountain Amusement Park. The proposed theme of the Park is a recreation of the Old West of the year 1858.

Magic Mountain is planned for young folk from 8 to 80. Located on a 600-acre site where Highway 40 passes through the foothills and enters the mountains, the Park is designed to include an authentic reproduction of an old-west village, a Cavalry Post and Stockade, entertainment and recreation facilities, a "Magic of Industry" exposition area, various "thrill" and educational rides, a Storybook Lane for the younger set and a full-scale narrow gauge train circling the main park area.

The idea for Magic Mountain was first conceived more than five years ago by Walter F. Cobb, a Denver business man, and sculptor John Sutton. Cobb is now President of Magic Mountain, Inc., and Sutton is Vice President.

Last July, Magic Mountain, Inc., signed a contract with the Marco Engineering Company of Los Angeles to design and build the Park and manage it during the first year of operation. Marco is headed by C. V. Wood, Jr., formerly executive vice president and manager of Disneyland.

At the same time, Magic Mountain, Inc., retained Howard Vineyard, then manager of operations at Disneyland, as General Manager. Heading the art staff for Magic Mountain are Wade Rubottom and Richard Kelsey, who served in like capacities at Disneyland.

It is proposed to open Magic Mountain Park during the summer of 1958.

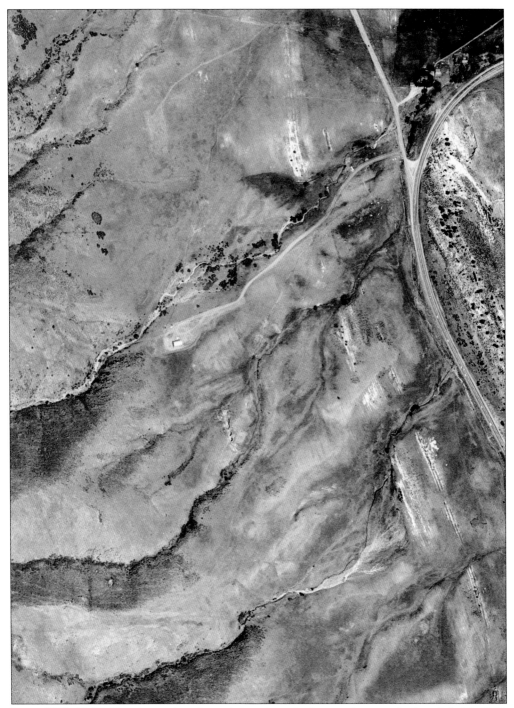

Just off US 40 (Colfax Avenue) is this pristine site, which was photographed on July 28, 1957, by the Colorado Aerial Photo Service as part of its regular series of scheduled flyovers of the front range and beyond. Magic Mountain's new location is the 600-acre Bockman Ranch site. See pages 50, 51, and 94 for progress photographs. (Courtesy of John Young, © 2015 Colorado Aerial Photo Service.)

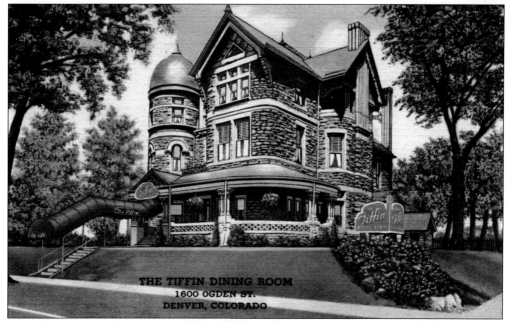

THE TIFFIN DINING ROOM
1600 OGDEN ST.
DENVER, COLORADO

According to the *Colorado Transcript* on July 25, 1957, "James V. McGoodwin, a partner in the Marco company, is now in Denver and has announced the leasing of the old Tiffin Mansion at Sixteenth and Ogden Avenue as design headquarters for Magic Mountain. A staff from Marco, augmented by Denver artists and designers, will work out of the historic 20 room mansion during the early stages of Magic Mountain development."

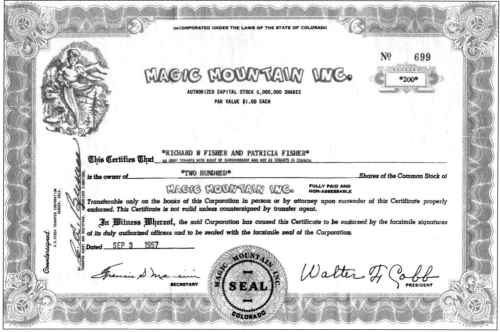

While construction commenced at Magic Mountain's new site, shares of stock were being sold by salesmen working for Hathaway Investment Corporation, whose main office was located at the Columbine Building, 1845 Sherman Street, Denver. (Courtesy of John Fisher.)

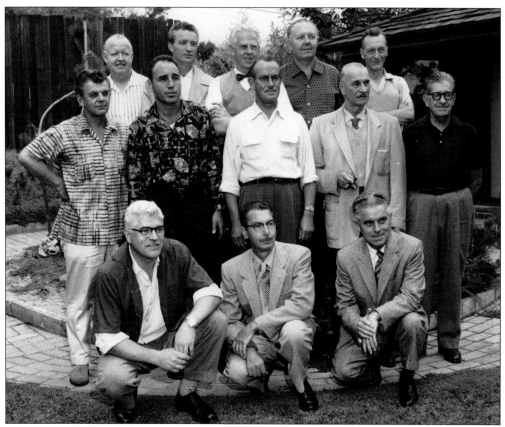

This photograph was taken in Los Angeles on September 18, 1957, of Marco Engineering's design team for Magic Mountain. From left to right are (first row) Richmond (Dick) Kelsey, John J. Thompson, and Wade B. Rubottom; (second row) William Dreis, Jerome Bowen, Theodore Ang, Joseph Babolnay, and Harry Johnson; (third row) Allan Abbott, Frank O. Barnette, Robert Stahler, Glen McComas, and Roland Hill. (Courtesy of the Cobb family collection.)

In addition to setting up design headquarters in Denver, Marco Engineering also rented space for artists and draftsmen at 7815 West Sixteenth Avenue in Lakewood. Shown here are Magic Mountain's lead art directors Wade B. Rubottom (left) and Dick Kelsey (right). This building was constructed in 1958 and is currently occupied by the Starr Center. (Courtesy of the Cobb family collection.)

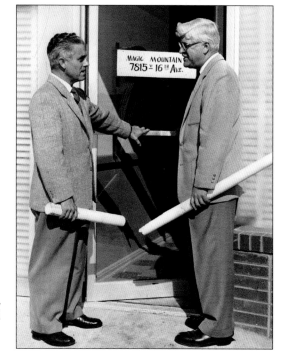

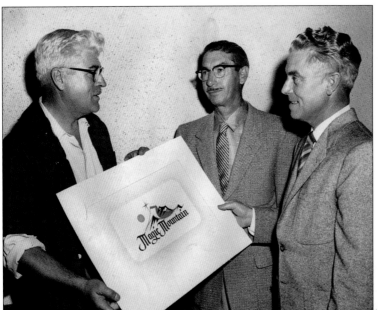

Three art directors for Magic Mountain are shown here with the park's iconic logo. From left to right are Dick Kelsey, John J. Thompson, and Wade B. Rubottom. (Courtesy of the Cobb family collection.)

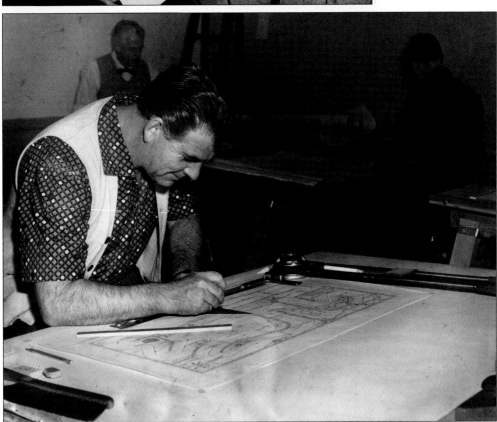

At the Lakewood Studio, one of Marco Engineering designers, William Dreis, is turning story lines for the Road Racer attraction into construction drawings. Directly behind Dreis is another designer, Robert Stahler. (Courtesy of the Cobb family collection.)

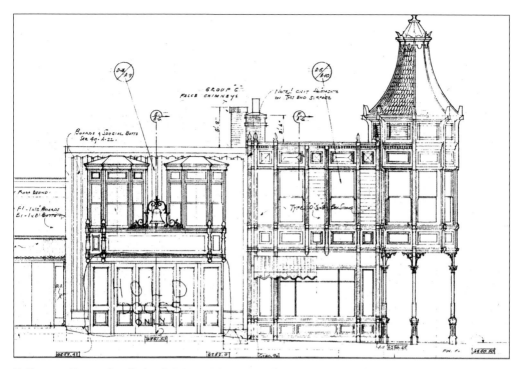

Following Disneyland's lead, Magic Mountain designers grouped several shops, services, or attractions into one larger structure sharing the same foundation pad and roof system. Boston's Pleasure Island had one block that housed the Diamond Lil Saloon, the Gazette print shop, the Chisholm Trail dark ride, exhibitor space, and even a small log jail all sharing the same building. Magic Mountain's Main Street was originally named Market Street with intersecting streets named First, Second, and Third Streets. This blueprint drawn at the Lakewood Studio show portions of Block C. (Both, courtesy of Jerry Kannapinn.)

DENVER	**MAGIC MOUNTAIN INC.** COLORADO		
REVISIONS	**PROJECT SECTION**	*MARKET STREET*	**No.** N-400
NO. DATE BY	**UNIT NAME**	B L O C K C	**No.** N-400-5
	DRAWING TITLE	*DETAIL NO. 5*	**SHEET NO.**
	SCALE 3/4" = 1'-0"	DATE	**A-10**
	DRAWN BY J. T.	APPROVED	
	CHECKED BY	APPROVED	
	VERIFY ALL DIMENSIONS AND CONDITIONS AT JOB SITE BEFORE PROCEEDING WITH WORK		TOTAL SHEETS
DESIGNED BY ART DIRECTORS: WADE B. RUBOTTOM AND DICK KELSEY			
1600 OGDEN — DENVER, COLORADO			
		PRINTS ISSUED	JAN 23 1959

Magic Mountain's iconic symbol was used on everything from its stagecoaches to its antique cars to its official stationery. (Courtesy of the Allen-Pike collection.)

Magic Mountain's tilt house was named the Magnetic House, Freedomland's was the Caso Loca, and Pleasure Island's was the Strange Shanty. This rendering is typical of Marco Engineering's designs done for all three tilt houses. Each attraction was a walk-through and filled with gravity-defying gags to disorientate the guests, and they worked great. One example is water or pool balls that would seem to be running uphill.

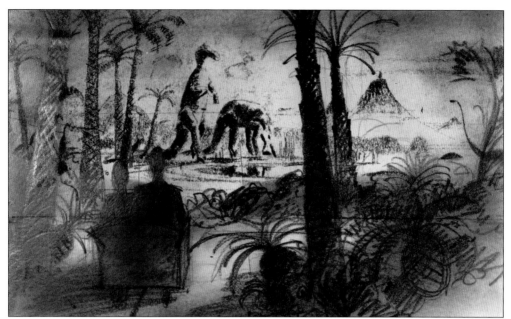

A thematic story line for Magic Mountain was developed by Marco Engineering designers. They incorporated some aspects of themes from the park's original location into their final design. Excerpts from this 1958 report, titled *The Magic Mountain Story*, will accompany the following renderings by Marco artists. The concept sketch (above) evolved to this artist's rendering (below) for the Creation of the World dark ride. The report stated, "This ride depicts the tremendous importance of prehistoric animals and plant life in the history of the Rocky Mountain Empire. In this ride will be seen the re-creation of prehistoric plant life and reconstruction of the animals that roamed this area at this point in history." (Above, courtesy of the Cobb family collection; below, courtesy of the Allen-Pike collection.)

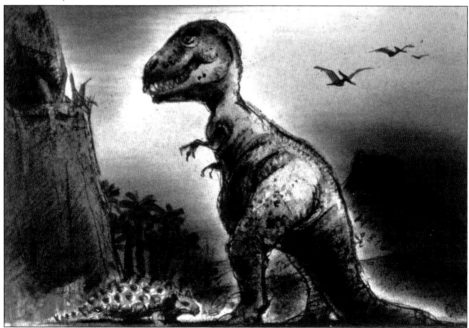

The following is from *The Magic Mountain Story*: "The entrance area is designed as an early cavalry fort and it is there that Magic Mountain pays tribute to the cavalry which played such a large part in the development of the West. Guests will be able to see authentic blockhouses and Indian defense systems." (Courtesy of the Allen-Pike collection.)

This rendering shows the park's main entrance area, looking toward the cavalry buildings. Note the snack stand below the blockhouse. Adjacent to the shaded seating area is a re-creation of an old medicine show. The report stated that "the story told here is one of the medicine shows coming to town and furnishing free entertainment in order to attract an audience and thereby sell some miraculous elixir." (Courtesy of the Allen-Pike collection.)

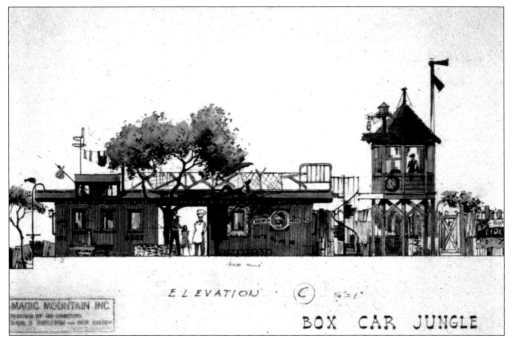

ELEVATION (C)

BOX CAR JUNGLE

MAGIC MOUNTAIN INC.

"Located by the railroad station is the Hobo Jungle. As the Magic Mountain Railroad Company disposed of worn-out freight cars, they were shunted off to the side. Bums and hobos made these freight cars into their homes. This will operate from two boxcars and will serve a delicious beef stew, served in tinware as the hobos would have used," stated the report. (Courtesy of the Allen-Pike collection.)

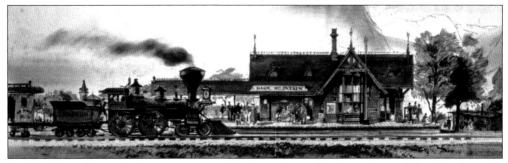

As *The Magic Mountain Story* continues, "Rising majestically above the park itself is the train station for the full scale narrow gauge train. This train will completely encircle Magic Mountain, affording the passenger a majestic view of Magic Mountain and its thirty-five million gallon reservoir, as well as a view of the Rocky Mountains and rock out-croppings of the surrounding area." (Courtesy of the Allen-Pike collection.)

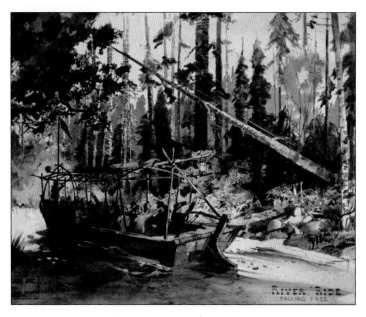

A section of *The Magic Mountain Story* details the River Ride as follows: "As the boat leaves the dock, a meadow scene is first visualized, showing all the small animals to this area. These animals, such as chipmunks, rabbits, owls, and beavers, will all be animated so that they appear to be real. Leaving this, the creaking sound of breaking wood is heard and an old deserted bridge falls, just missing the boat." (Courtesy of the Allen-Pike collection.)

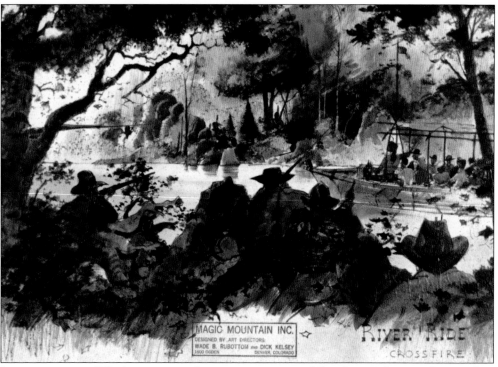

It goes on to state, "The boat turns and sees a gorgeous waterfall with an Indian maiden standing atop it. The boat turns to avert the waterfall and out of the reeds glides an Indian war canoe. The chief stands up in the boat, pulls back his bow as if to shoot an arrow. But an even worse thing is about to happen, as the boat is now caught in the crossfire of a terrifying fuselage of shots between the cowboys on one bank and the Indians on the other." (Courtesy of the Allen-Pike collection.)

"Past the next turn, the boat comes across an old deserted ghost town. The boat turns to continue its journey and barely averts being sucked into a whirlpool. In dodging the whirlpool, the boat is taken into fierce rapids. Devices which are located under the water rock the boat making it seem as if the rapids were about to capsize the boat. The boat operator successfully navigates the rapids and brings the boat safely back into the landing dock," documents *The Magic Mountain Story*. (Courtesy of the Allen-Pike collection.)

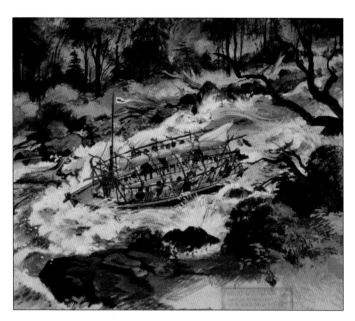

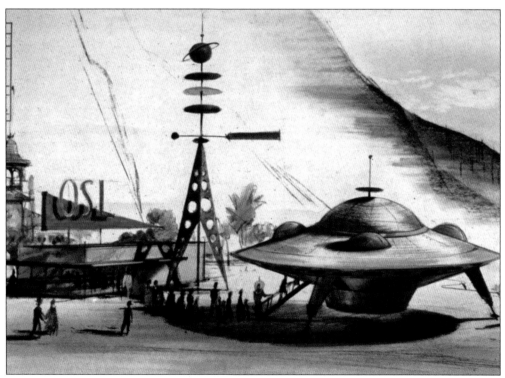

The report states, "In the Magic of Industry area will be found the 'Outer Space Land' ride. The Outer Space plane is a 'flying saucer' type aircraft which will simulate a flight at speeds up to 3,000 miles per hour and altitudes of 60,000 feet. The ship will start to vibrate as though it were actually leaving Earth. Ten minutes later, the flight is over and the passengers disembark, believing they have actually flown." (Courtesy of the Allen-Pike collection.)

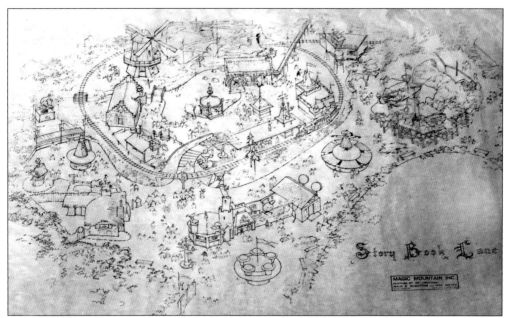

Marco's designers incorporated Magic Mountain's original Storybook Lane concept as described in this plan and the following sample of renderings. Below is a sketch of the ice cream stand. According to *The Magic Mountain Story*, "Adjacent to the Magic Mountain Fairgrounds is Storybook Lane, an area of three acres of charming rides and amusements devoted to the small children of 2 to 6 years of age." Also, it states that "refreshment stands in this area will be built in the shape of ice cream cones, candy boxes, and thatched roof houses." (Above, courtesy of Terry Raney; below, courtesy of the Cobb family collection.)

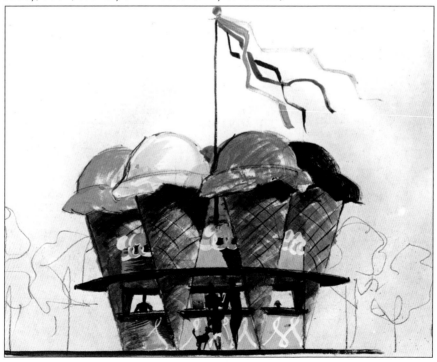

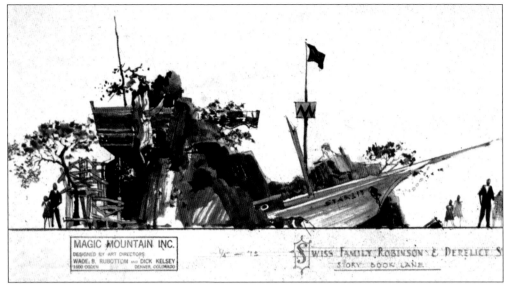

The Magic Mountain Story continues as follows: "A tiny little train takes children on a trip in a land of windmills, castles and pastoral scenes of small animals." Shown above, "a walk-through which will depict the Swiss Family Robinson, takes children through the hull of the wrecked ship which the Swiss Family Robinson used as their home." Also, "a miniature penny arcade will have games specially designed for the enjoyment of children of this age." Shown below is a castle with storybook character Humpty Dumpty. (Both, courtesy of the Allen-Pike collection.)

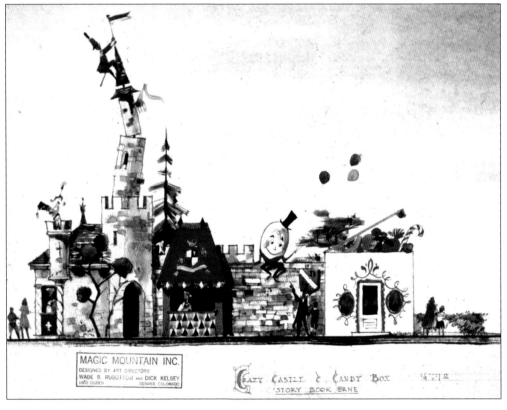

A variety of dining venues were drawn by Marco's designers, which were themed throughout the park. One rendering was drawn for a proposed fish house restaurant designed as a "three masted schooner, serving sea foods in a marine atmosphere," according to the report. Shown above was the Mexican outdoor restaurant. Shown below is the Fish Fry restaurant. (Both, courtesy of the Allen-Pike collection.)

Two

CONSTRUCTION

Before Disneyland, locations for traditional amusement parks took advantage of natural environments, such as lakeshores or oceanfront properties. Starting with Disneyland, investors evaluating potential sites for theme parks would simply add lakes, mountains, and so on to create the desired effect. Using Disneyland as an example, berms were designed to isolate proposed parks from the outside world. Magic Mountain's site required massive amounts of earth moving. In addition, a lake and reservoir were carved out. Boston's Pleasure Island was built in a swampy wetland, and New York's Freedomland sat on top of a former landfill, which was formerly a tidal basin hugging the Hutchinson River. The bottom line is theme parks could be and are constructed almost anywhere thanks to Disneyland's playbook. The Marco-designed parks, which mimicked Disneyland, were built without traditional amusement park attractions such as roller coasters and bumper cars. Following Walt Disney's vision, Magic Mountain's founder, Walter F. Cobb, and Pleasure Island's William Hawkes created family recreation centers that focused on education and fun bundled into one. Freedomland also shared the same concept and was the largest of the Marco-designed parks, even larger than the original Disneyland. Freedomland was themed out in the shape of the United States and had its guests experience 200 years of American history. Interestingly, in the mid-1990s, Disney made a failed attempt at creating a similar story line as Freedomland, named Disney America, which was to be located in Northern Virginia.

Throughout this book is this reminder—$1 in 1957 had the same buying power as $8.57 does in 2016. Unlike the financing for Disneyland, Pleasure Island, and Freedomland, Magic Mountain relied solely on sales of common stock, which would turn out to be problematic, continually pushing the park's opening date down the road. Plans were for six themed areas—Cavalry Post and Stockade, Centennial City, Fairgrounds, River Ride, Magic of Industry, and Storybook Lane. Unfortunately, due to lack of funds, only the first two areas were completed. Aspects of the remaining four areas were carried over to Freedomland's story line. This chapter is dedicated to the late Winfield Hubbard, who was Magic Mountain's special effects chief.

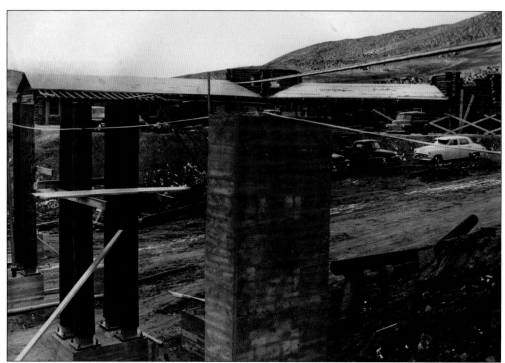

Both of these photographs were taken on the same day in December 1957. Shown above is Magic Mountain Railroad's trestle bridge and the Cavalry Post and Stockade under construction. Shown below is Magic Mountain's Shooting Gallery under construction. From the *Colorado Transcript* on January 30, 1958, reads, "Cavalry Post completed at Magic Mountain—public dedication and flag raising ceremonies will be held Saturday morning, Feb 1, 11:00AM at Magic Mountain heralding the completion of the first building at the site. . . . Participating in Saturday's ceremonies, during which the flag will be raised in front of the Cavalry Post, will be: the Lakewood Westernaires Cavalry Troop, the Buffalo Bill Riding Club, the Deverettes Girls' Band, Sheriff Scotty (KBTV), Pete Smythe (KOA) and Fred and Fae Taylor (KLZ-TV). The Cavalry building will serve as administration headquarters when the park opens early next summer." (Both, courtesy of the Cobb family collection.)

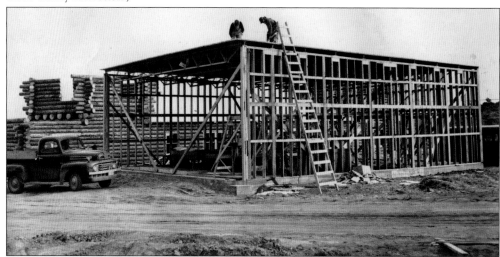

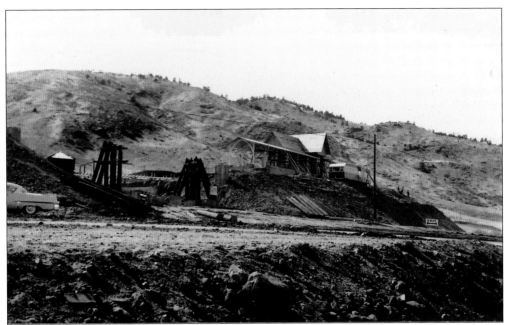

This photograph was taken March 30, 1958, showing progress on Magic Mountain Railroad's trestle bridge at the park's entrance and the train station. Note the exit sign, the original entrance to the park was at the intersection of Route US 40 and State Highway 93 that connects Golden to Boulder. (Courtesy of the Colorado Railroad Museum, the John Buvinger Collection.)

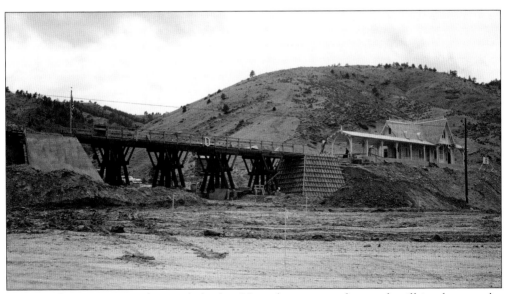

Here, work continues on the trestle bridge. Note the concrete formwork still in place on the right. Magic Mountain's train station is taking shape. According to Monty Pike, the interior of this station was paneled in wormy chestnut planking, which was very expensive. (Courtesy of the Allen-Pike collection.)

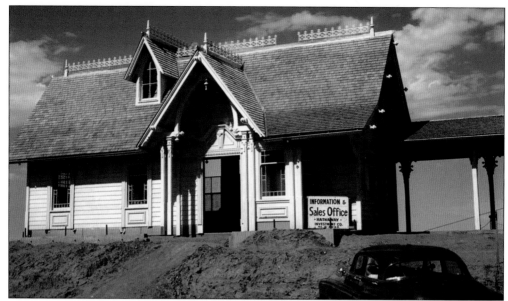

A letter to stockholders reminded them that the first annual stockholder's meeting would be held at the Magic Mountain park at 1:00 p.m. on Wednesday, July 23, 1958. The following is an interesting excerpt from the letter: "$1,272,945.58 has been raised through the public sale of stock. This constitutes about one-third of the projected goal. The railroad station is 95% complete [above] and the narrow gauge engine is now in the D.&R.G. shop at Alamosa for renovation. Steel is up and other exterior work has started on the main buildings in Centennial City. The stone work at the entrance is complete. 80% of all leveling, grading, and trenching of the River Ride is done. Construction on the 35 million gallon reservoir is complete and the Hugh Lake is now being filled from Apex Gulch. In all, over one million yards of dirt has been moved, representing more than ¼ million dollars expenditure." Below is the new trestle bridge, minus the track. (Both, courtesy of Ron and Stephen Peck.)

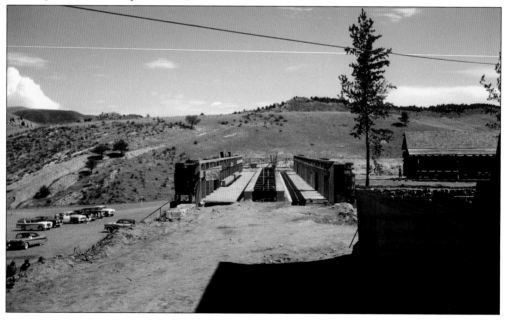

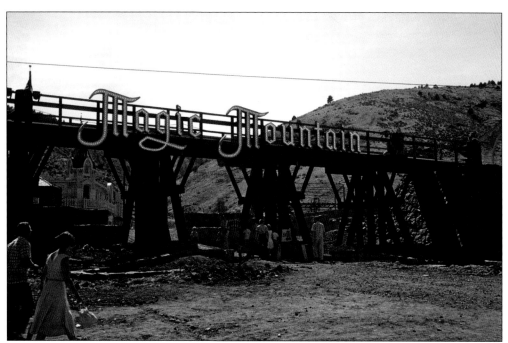

Both of these photographs were taken the same day in 1958 for a panoramic view of the park's entrance from the parking lot. Judging by construction progress and short sleeves, these photographs were taken in late summer. Starting in 1958, the park was open to visitors (above) on weekends to view construction progress and attend tours conducted by the sales department offering Magic Mountain, Inc., stock for sale to potential investors. In the photograph below, the caboose is on a temporary storage track. (Both, courtesy of Ron and Stephen Peck.)

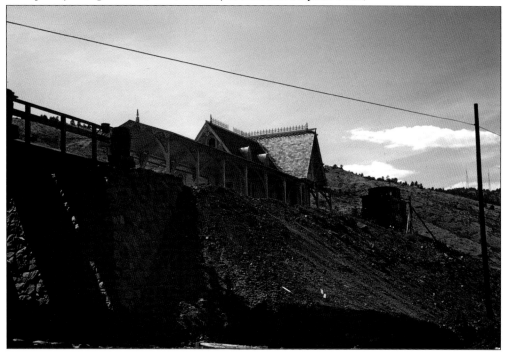

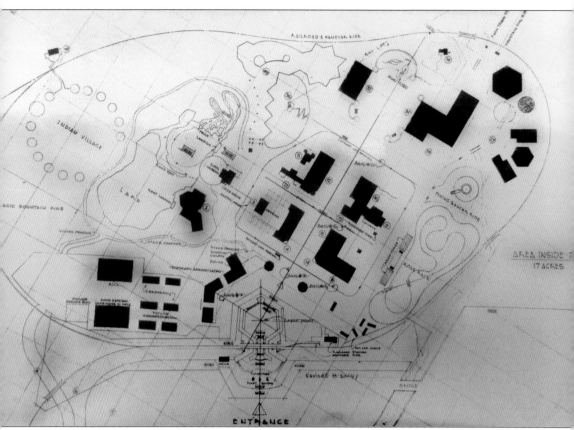

Shown here is a very rare blueprint of Magic Mountain's original layout at what would be known as Parcel Two to potential stockholders. Parcel One was the former and original site on West Thirty-Second Avenue. By reviewing photographs selected for this book and accompanying text, readers can review this plan to see what was originally planned and ultimately built. For instance, the Road Racer attraction ended up where the buildings to the left of the main entrance were; originally, that area was planned to be the backstage and maintenance area for the completed park. (Courtesy of Rick Gardner.)

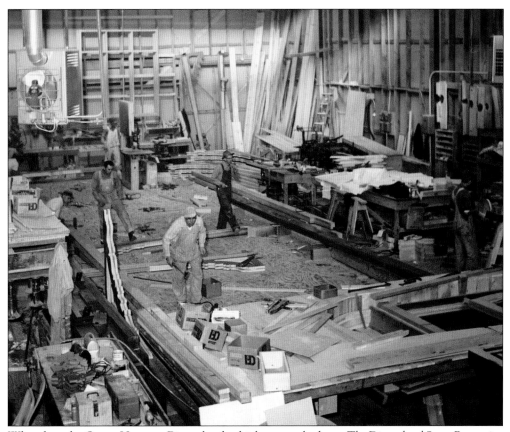

What does the Opera House at Disneyland, which currently shows *The Disneyland Story Presenting Great Moments with Mr. Lincoln*; the Diamond Lil Saloon at Boston's Pleasure Island; and the backstage buildings at Freedomland have in common with this photograph inside Magic Mountain's premiere dark ride the Creation of the World? The answer is that all of these buildings were the first ones constructed to be shops or, in Disneyland's case, the mill. Exteriors of the respective parks were prefabricated indoors, bypassing climate conditions outdoors, therefore accelerating productivity to meet target deadlines. By analyzing this photograph, one can see the detail that shows up in the following photographs as Magic Mountain's four core blocks come to life. Below, Monty Pike is outside the shop for a photo opportunity. After work in the shops was completed, the buildings were fitted out for their intended use. (Above, photograph by Stanley W. Zamonski; below, courtesy of the Allen-Pike collection.)

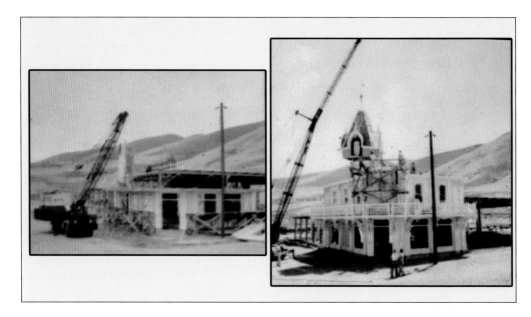

After the steel frames were constructed for the main block—Buildings A, B, C, and D—the exteriors were installed, which came out of the shop. These photographs show the first exteriors being installed at the Block A complex on the left side of Market and First Streets. Shown below are one of the blockhouses and seating area under construction, mirroring an artist's rendering shown on page 26. Beyond the park guide and guests is the Block D complex. (Both, courtesy of the Allen-Pike collection.)

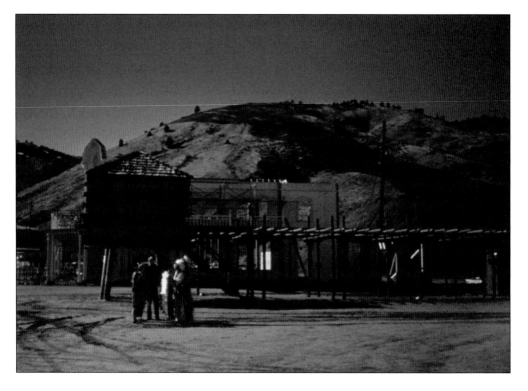

Beginning with Block A, which is directly across from the stockade post, exterior panels are shown here attached to their steel frames. Google "Construction in Disneyland YouTube" and see that this was a similar method of construction for that park's Main Street buildings. (Courtesy of Ron and Stephen Peck.)

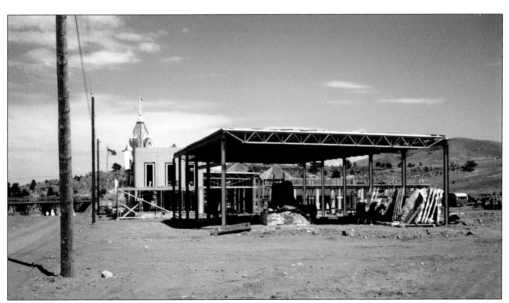

Looking toward the main entrance is the steel frame for Block B minus the exterior, with Block A in the background. (Courtesy of Ron and Stephen Peck.)

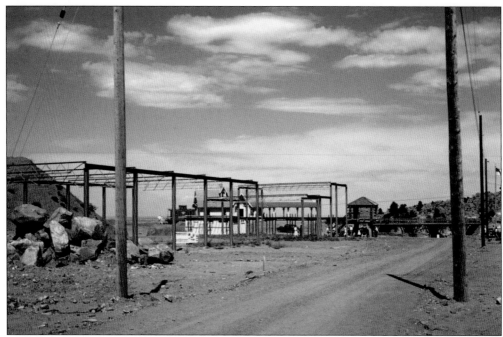

Looking toward the main entrance on the left side of Market Street is the steel framework for Blocks C (rear) and D (front). Note the elevated frame on Block D that would be home to the music hall (see page 93). (Courtesy of Ron and Stephen Peck.)

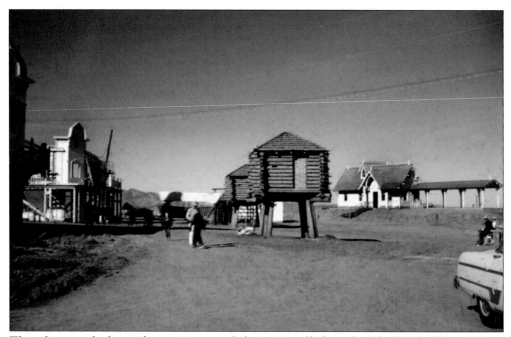

This photograph shows the exterior panels being installed on the Block D building. Magic Mountain's core building exteriors were installed in this order: A, B, C, and, lastly, D. (Courtesy of the Allen-Pike collection.)

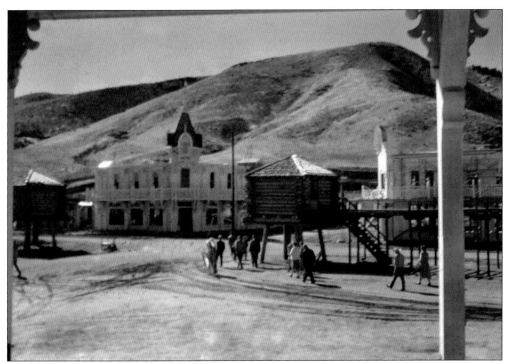

This photograph was taken from the train station toward First Street and Market Street. In a report from October 1957, "New stories and pictures at least once a week in the daily papers help play up the stock selling feature of the park." Above is one of these progress tours. (Courtesy of the Allen-Pike collection.)

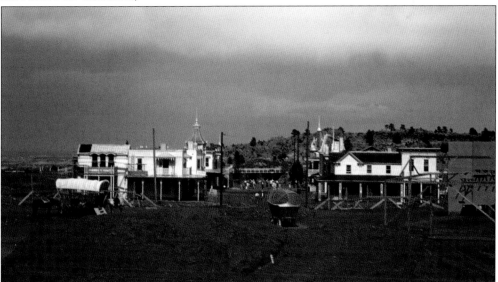

Looking down toward the main entrance with Blocks A, B, C, and D exteriors installed, construction continues during the 1958 season. Shown in the distance in this weekend photograph on Market Street are potential investors reviewing the park's progress. Just like with Disneyland, a substantial portion of the total budget was spent on site work and belowground infrastructure the public never sees. (Courtesy of Ron and Stephen Peck.)

In a story from the *Colorado Transcript* dated July 11, 1957, is the following excerpt: "The site is plainly marked with signs, lights, and flags. Denver area residents are invited to bring guests to inspect the covered wagons now on display." These are probably the covered wagons in front of the trading post. (Courtesy of Ron and Stephen Peck.)

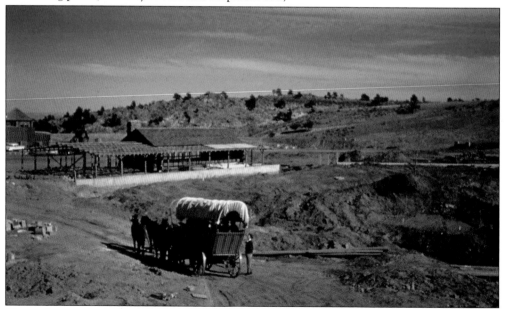

Shown here under construction is the River Ride premier attraction. This is the one the kids would be running to once the 5,000-pound station wagon hit the 3,000-car parking lot. Naturally, as part of the queuing area, is the Disney-inspired gift shop, also known as the Trading Post. (Courtesy of the Allen-Pike collection.)

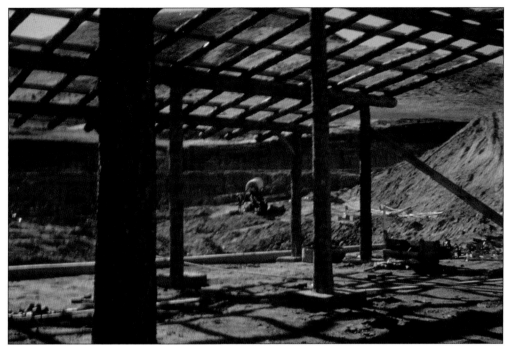

This is the queuing area for what would be the equivalent to Disneyland's Jungle Cruise ride. In late-1950 currency, a total of $450,000 was spent on this attraction. Note the Conestoga wagon pulling guests around during the weekend tours while Magic Mountain was under construction during the 1958 season. (Courtesy of the Allen-Pike collection.)

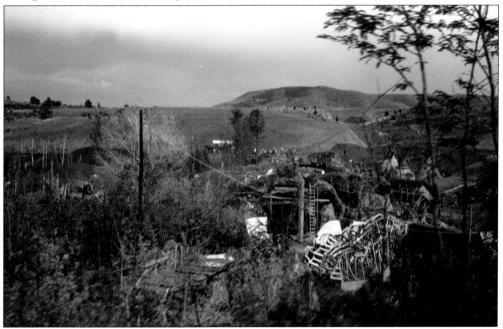

Construction on the River Ride shows the waterfall structure and formwork for fake rocks (think Disney's Big Thunder Mountain). Beyond this site, on the right, is Magic Mountain's Indian Village with authentic teepees. (Courtesy of Ron and Stephen Peck.)

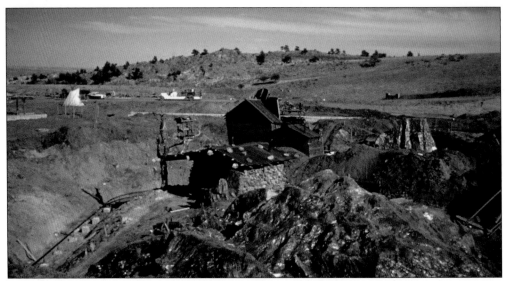

Shown in this photograph on the left is the rail system for the boats traveling through this attraction. The realistic rock formations are in place along with some of the gags, which help guests experience the story line from launch to disembarkment. In addition to the gags, the narration by the boat captain is a large part of the show. The back side of Ghost Town is shown at center in the photograph. (Courtesy of the Allen-Pike collection.)

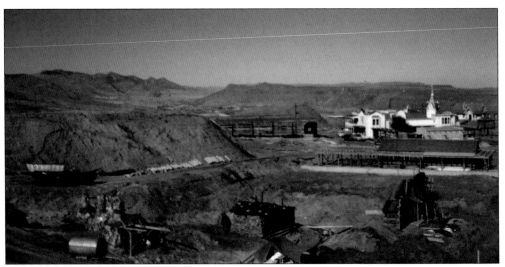

Shown here is an overview of construction during the 1958 season with the River Ride in the foreground. The four main core buildings are in various stages of construction. (Courtesy of the Allen-Pike collection.)

The following excerpt is from a story from the *Rocky Mountain News* on August 2, 1959, about Magic Mountain's special effects chief, Winfield Hubbard: "The Ghost Town is one of Hubbard's most imaginative creations for the Riverboat Ride. A bony bartender stands at the saloon door, holding a bottle. Another skeleton, wearing only one weathered boot, dangles from the hangman's tree. As the boat goes by, vultures perched on the dilapidated rooftops flap their wings and squawk." (Courtesy of the Denver Public Library, Western Collection, Call No. 2129.)

A mock-up boat and rail system similar to Disneyland's Jungle Cruise are shown in this photograph. A national story about Magic Mountain states, "This attraction is a winding 1,600 foot water route. The ride will have a total of 55 sight gags ranging from an Indian canoe raid, falling bridge and a battle between two mountain goats to cowboys and Indians shooting at each other from opposite banks of the river." (Courtesy of the Allen-Pike collection.)

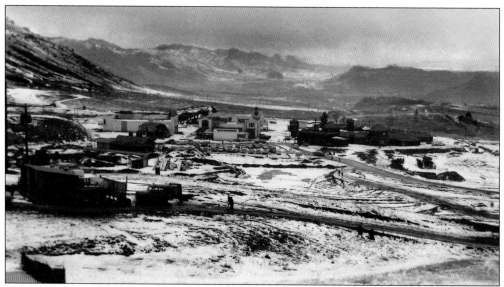

This progress photograph was taken February 22, 1959. Just like at two other Marco Engineering–designed theme parks, Pleasure Island and Freedomland, work continued through the winter months, particularly in the shop. (Courtesy of the Colorado Railroad Museum, the John Buvinger Collection.)

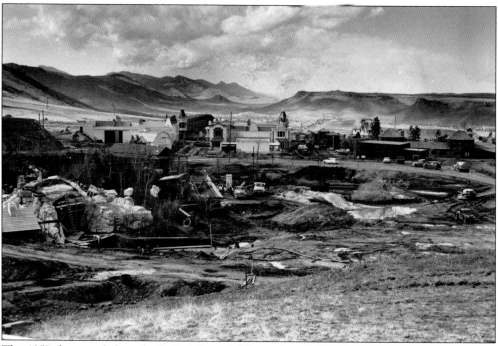

This 1959 photograph from the *Rocky Mountain News* was probably taken in early spring. According to the *Rocky Mountain News* on August 2, 1959, "Keelboats for the ride are under construction now in Magic Mountain's shop. The boats will be 32 feet long and will accommodate 32 passengers each." The newspaper went on to state, "One of the most beautiful effects is a copy of the Lascaux Caves of France [shown above] covered with replicas of the paintings made by prehistoric man." (Courtesy of the Denver Public Library, Western Collection, Call No. 2129.)

Inside Magic Mountain's shop is a welder, on the left, working on a pair of fighting rams designed to pull back and butt their heads together as the River Ride's keelboats pass by this gag. Three craftsmen are modeling a prop, which is probably for the same attraction. From local newspaper accounts, Winfield Hubbard expected to build 15 or 18 full-sized dinosaurs of various species for the dark ride this building was designed for. (Photograph by Stanley W. Zamonski.)

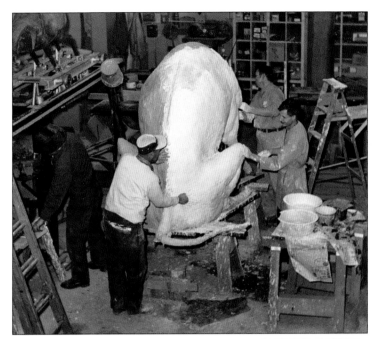

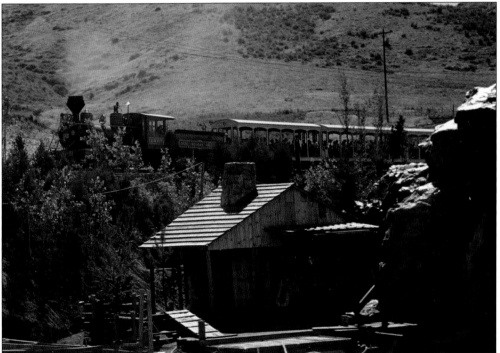

This is a great photograph showing the Magic Mountain Railroad and a portion of the River Ride attraction with a re-creation of a period building from the 1800s. The following is an excerpt from the *Rocky Mountain News* on August 2, 1959: "Few people know that Winfield Hubbard is responsible for the 'magic' of Magic Mountain. But thousands are viewing his work at the park with amazement and amusement. Last Sunday 14,000 people toured Magic Mountain." (Courtesy of Ron and Stephen Peck.)

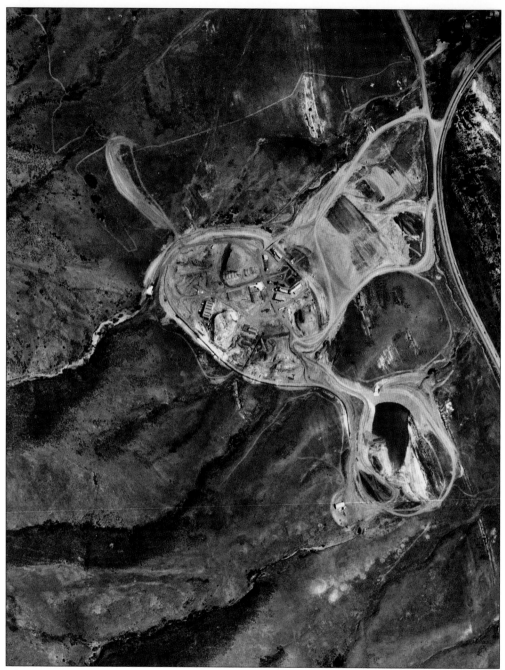

This photograph was taken on July 17, 1958, over Magic Mountain with US 40 off to the right. The River Ride layout is shown just about in the center to the right of a large rock formation exposed from the 1957 grading operation. The reservoir is shown at lower right with the rough layout for the Magic Mountain Railroad track bed. (Courtesy of John Young, © 2015 Colorado Aerial Photo Service.)

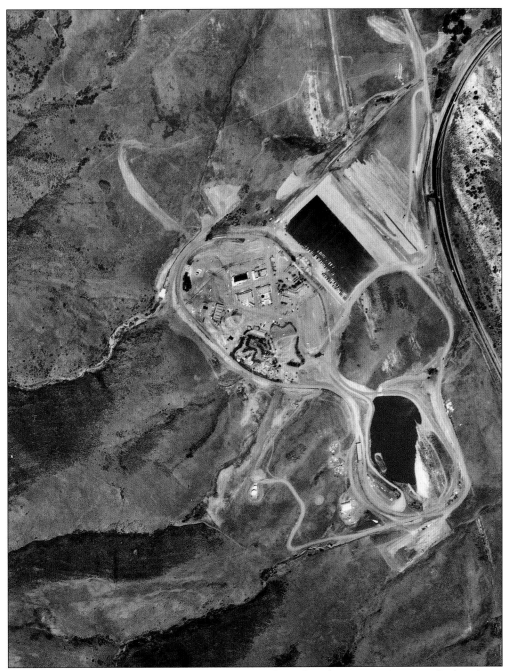

This photograph was taken on July 9, 1959, a few days after the Magic Mountain Railroad was dedicated. The parking lot is visible as are the four core buildings, Blocks A, B, C, and D. Work continues on the River Ride attraction. The train tunnel and maintenance shed can be seen to the left of the reservoir. The shop that was designed for a dark ride is to the left of the River Ride. (Courtesy of John Young, © 2015 Colorado Aerial Photo Service.)

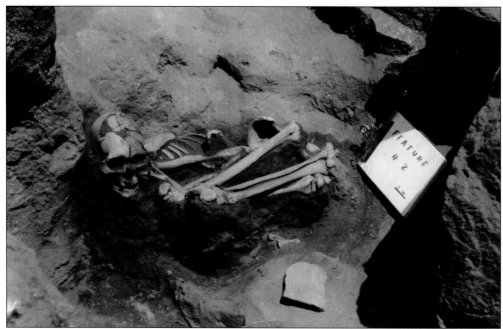

This is not Winfield Hubbard's handiwork but a photograph of a very important archaeological dig performed at Magic Mountain during 1959 and 1960. Twenty-five hundred artifacts dating back 5,000 years came from this dig. Google "Excavations at Magic Mountain, Denver Museum of Natural History" to read the 225-page report. The following excerpt is from page 51 of *Excavations at Magic Mountain: A Diachronic Study of Plains-Southwest Relations*: "Circumstances of Discovery: Encountered by Chance: In the process of excavating a water-pipe trench to supply nearby amusement park, operator of a backhoe cut vertically through pit burial belonging to woodland zone." (Courtesy of the Joe Lunn family collection.)

This photograph was taken on July 8, 1960, during Magic Mountain's premiere season. Although the narrow-gauge train attraction operated on weekends during the 1959 season, much of the park was still not completed, as shown from the sign above for the 1960 season. (Courtesy of the Colorado Railroad Museum, the John Buvinger Collection.)

Three

MAGIC MOUNTAIN RAILROAD

Following Disneyland's lead, Marco designers planned several high-capacity attractions. Capacity is determined on how many guests, per hour, per ride. The Magic Mountain Railroad would be the only high-capacity attraction completed. The other Marco-designed parks, Pleasure Island and Freedomland, also had high-capacity narrow-gauge excursion trains. In fact, Freedomland had two running simultaneously.

Bill Robie grew up one town over from Pleasure Island and worked as a fireman on the Pleasure Island & Western Railroad in the early 1960s. Robie permanently relocated to Golden, Colorado, to attend the Colorado School of Mines. The following excerpt is Robie's account on the history of Magic Mountain Railroad No. 42:

> The steam locomotive used at Magic Mountain was built in 1887 by Baldwin Locomotive Works in Philadelphia, Pennsylvania, with Builder Number 8626. It is a "Consolidation" type locomotive with a 2-8-0 wheel arrangement and operates on 3' gauge track. It first operated on the Denver and Rio Grande Railroad as No. 420. The Rio Grande purchased it new for a little more than $8,000. From 1916 to 1953 it operated on the Rio Grande Southern Railroad in southwestern Colorado as No. 42. In November, 1953, it was acquired in partnership by Robert W. Richardson and Carl A. Helfin for display at the Narrow Gauge Motel in Alamosa, Colorado. In February, 1958, No. 42 was sold by Helfin, as part of his share of dividing the partnership assets, to the developers of the proposed Magic Mountain theme park in Golden, Colorado, for $5,000. Boiler and mechanical restoration, and conversion to oil-burning, were completed at Magic Mountain in the recently completed train shed where it subsequently operated during the 1959 and 1960 seasons, beginning on July 4, 1959.

Thankfully, for generations of railroad historians, this author had the opportunity to conduct a videotaped interview with Monty Pike. His recollection of purchasing No. 42, as an agent for Magic Mountain, Inc., is amazing. It is quite a story! Pike's memory is spot-on. He recalled asking for and receiving original blueprints for No. 42 from Baldwin Locomotive Works to aid in its restoration.

January 2, 1958

Mr. Arthur Stoddard, President
Union Pacific Railroad
Omaha, Nebraska

Dear Mr. Stoddard:

We are, at the present time, designing and constructing a multi-million dollar amusement park in Denver, Colorado. We feel that this will be one of the most exciting developments to happen in the Rocky Mountain Empire in recent years. All of the executives and art directors on this project have been associated with Walt Disney for many years and a result is a desire to create an amusement park as imaginative and beautiful as Disneyland.

It is our intention to encompass the entire 40 acres of our amusement park with a full-scale narrow gauge railroad, consisting of a locomotive, tender, and four or five passenger cars. It is most difficult to locate equipment of this nature, and therefore, I am asking your help in helping us locate this equipment. The condition does not matter too much as we can refurbish it ourselves.

I am sure that you would like to see a narrow gauge railroad in operation in a place as unique as Magic Mountain will be. We will appreciate any assistance that you can be to us in this matter.

Yours very truly,
HOWARD VINEYARD
Manager

HV:mm

BCC - Cal Pond
Monty Pike

This is an interesting memo from Magic Mountain's manager, Howard Vineyard, seeking help from the Union Pacific Railroad. Ultimately, the equipment would be sourced elsewhere. Meanwhile, an article dated October 20, 1958, reads, "A reproduction of an early day narrow-gauge railroad station has been completed, and the roadbed for the train has been graded. A narrow-gauge locomotive has been obtained and is being fitted." (Courtesy of the Allen-Pike collection.)

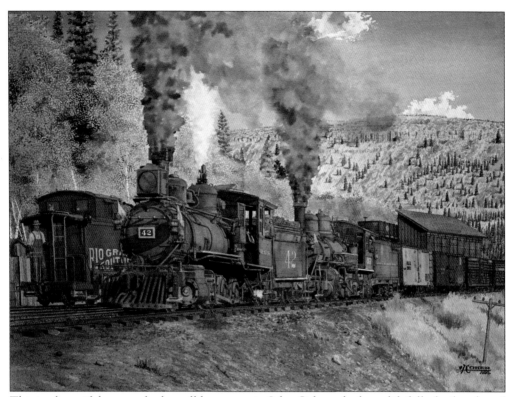

This is a beautiful watercolor by well-known artist John Coker, who has a life full of railroads and art. This scene is from early fall 1941 at Vance Junction, five miles west of Telluride. Shown with Rio Grande Southern (RGS) No. 42 is locomotive No. 463. For this locomotive's unique history, Google "Friends of the Cumbres & Toltec Scenic Railroad." (Courtesy of Coker Railroad Art.)

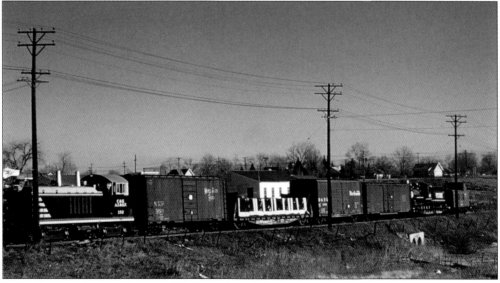

This photograph, dated January 12, 1959, shows Magic Mountain Railroad's locomotive No. 42 on the way to Golden (near Simms Street in Lakewood), where it was loaded onto a tractor trailer truck for the move to Magic Mountain. (Courtesy of Western Rail Images.)

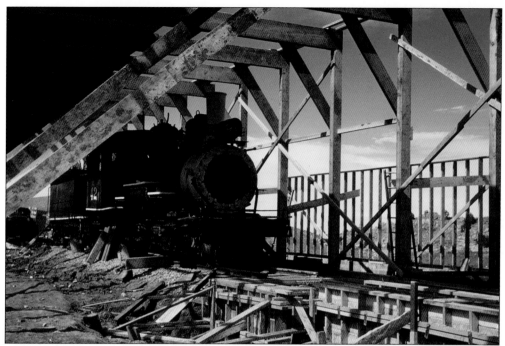

This photograph was taken April 26, 1959, while the Magic Mountain Railroad shed was under construction. No. 42 is shown on the maintenance track with the drop pit concrete forms in place. The stud wall going up to the right of No. 42 is the maintenance and tool shed (see page 89). (Courtesy of Western Rail Images.)

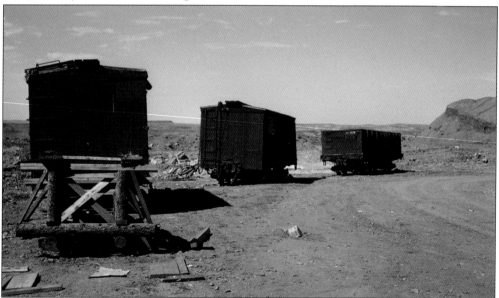

Two boxcars and a gondola car are shown at this unique off-loading platform. The trailers transporting these cars to the site backed up to the temporary ramp, and the cars were simply rolled off the trailer. The entire upper portion of the two boxcars and gondola car were removed, and Magic Mountain excursion cars were built on the remaining underframe and trucks. (Courtesy of Ron and Stephen Peck.)

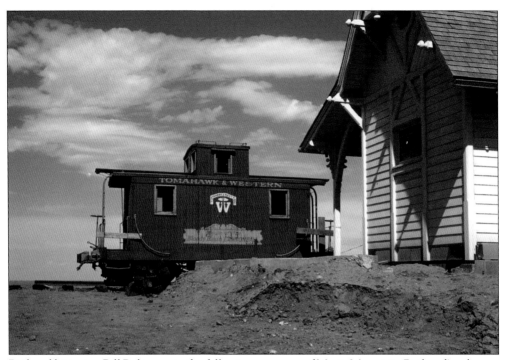

Railroad historian Bill Robie wrote the following summary of Magic Mountain Railroad's caboose: "The caboose was formerly Denver & Rio Grande No. 0510, then Rio Grande Southern No. 0409. After being used in the 1950 movie 'Ticket to Tomahawk,' No. 0409 apparently went to Cripple Creek, Colorado, for display. The caboose was still marked Tomahawk & Western [shown above] from its use in the movie when it first arrived at Magic Mountain." *Ticket to Tomahawk* can be viewed on YouTube. According to Robie, "The window, seating, and cupola arrangements on No. 0409 were reconfigured shortly after arriving at Magic Mountain." Shown below is Magic Mountain's caboose in Monument, Colorado. The photograph was taken February 24, 1969 (see page 87). (Above, courtesy of Ron and Stephen Pike; below, courtesy of Western Rail Images.)

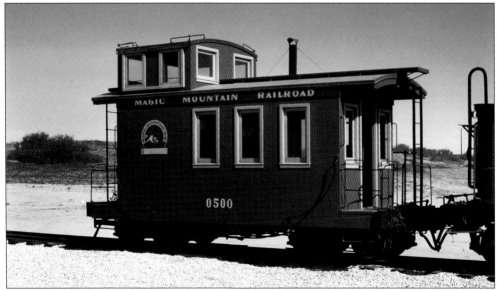

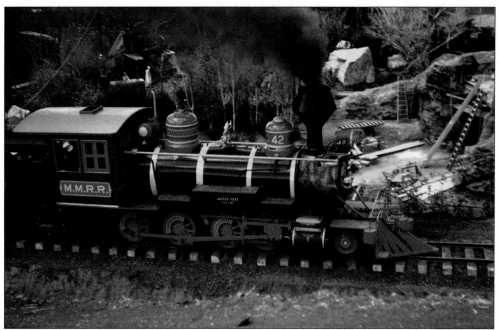

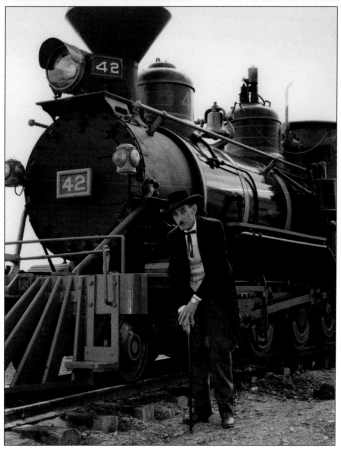

The photograph above was taken on July 2, 1959, during a test run of Magic Mountain Railroad's No. 42, its tender, and three excursion cars. The caboose was still being restored at this point. Note the beautiful restoration job on No. 42 with the River Ride attraction under construction beyond the tracks. The photograph at left is a close-up of No. 42 with one of Magic Mountain's character actors. According to Monty Pike, one of the volunteers who restored the engine supplied the replacement smoke stack for aesthetic purposes. (Above, courtesy of Western Rail Images; left, courtesy of the Allen-Pike collection.)

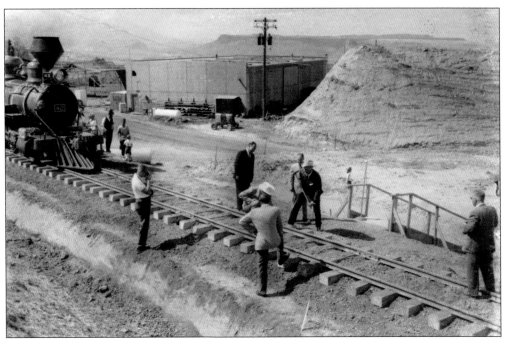

This photograph was taken July 4, 1959, during Magic Mountain's centennial construction preview celebrations. Dan Thornton, Colorado's former governor from 1951 to 1955, drives the Golden Spike held by Allen J. Lefferdink (kneeling) at the dedication ceremonies for the Magic Mountain Railroad. Just behind Lefferdink is general manager Jim V. McGoodwin. According to Leroy Allen, the rock formation beyond the tracks was named "Big Rock Candy Mountain." The large building is the shop that was constructed to be a dark ride (see page 25). (Courtesy of the Joe Lunn family collection.)

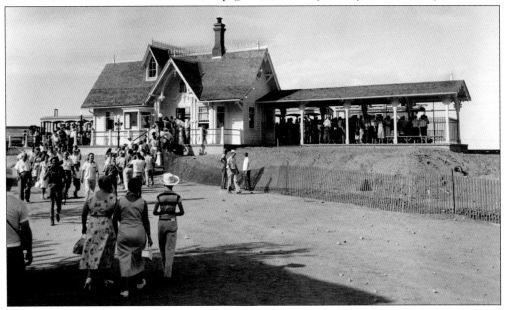

This photograph from the 1959 season shows just how popular the Magic Mountain Railroad attraction was. Although this was a ticketed ride, parking and admission to the park were free. (Courtesy of the Allen-Pike collection.)

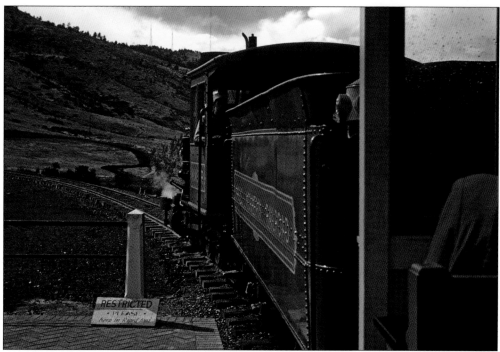

The Magic Mountain Railroad train leaves the station (above) for a reportedly 12-minute journey along the 7,500-foot route. The track configuration consisted of a dogbone-style layout with loops at both ends (as shown on page 51). The photograph below shows the train departing out of the dogbone cut heading toward the station. Note the Conestoga wagon above the cut. (Both, courtesy of Ron and Stephen Peck.)

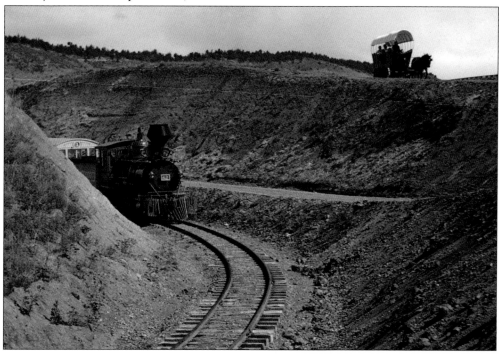

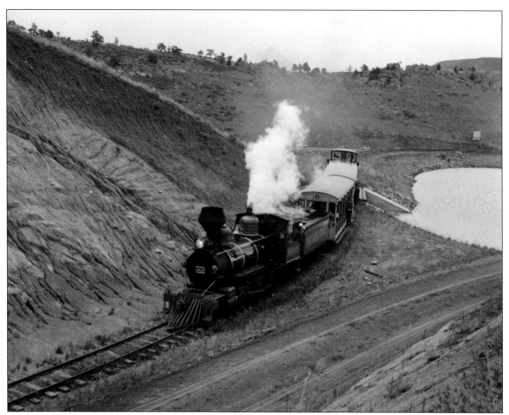

The photograph above shows the Magic Mountain Railroad's train heading back through the dogbone cut after going through the train shed tunnel and circling around the Magic Mountain reservoir. Note the overflow spillway by the caboose. Shown below is the train heading back toward the station past the Administration Building. (Above, courtesy of the Denver Public Library, Western Collection, Call No. 2129; below, courtesy of Ron and Stephen Peck.)

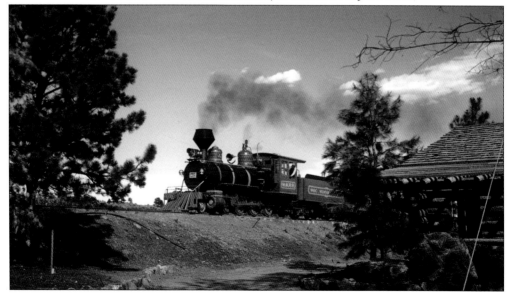

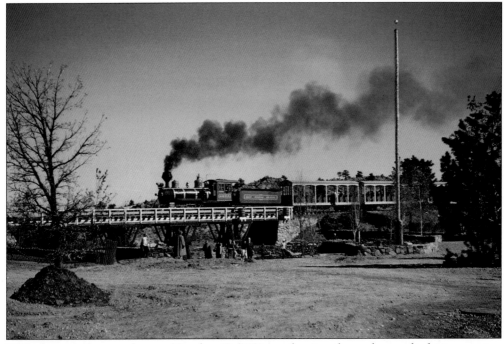

This photograph was taken on October 17, 1959, confirming the park stretched its operating season for the weekend audience. The Magic Mountain Railroad train is shown passing over the main entrance on its return trip to the station. (Courtesy of Western Rail Images.)

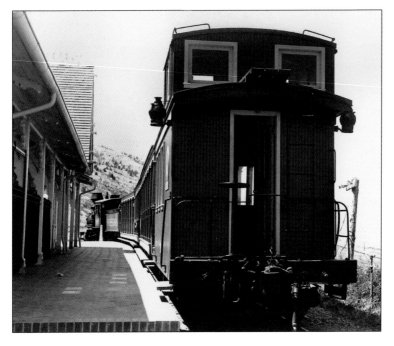

This photograph was taken on July 8, 1960, and shows a great view of Magic Mountain Railroad's caboose. (Courtesy of the Colorado Railway Museum, the John Buvinger Collection.)

Four

SHOWTIME

From Magic Mountain's original site to its final location and from Walter F. Cobb's leadership to Allen J. Lefferdink, it would take a spreadsheet to name all the players involved in this very complicated story. Officers of the original Magic Mountain Corporation were Cobb, president; John C. Sutton, vice president; Francis S. Mancini, secretary; and Calvin Pond, treasurer. Directors included Claude M. Hathaway, George N. Winder, Byton A. Anderson, William A. Nies, Raymond W. Near, Francis J. Ford, Louis E. Chance, James H. Williams, and Dr. H.D. Niblack. Ultimately, these gentlemen set the stage for entertainment and attractions discussed in this chapter. It should be noted that Magic Mountain's first general manager, Howard Vineyard, hired by Marco, was previously the operations manager at Disneyland. The park's next general manager was Jim McGoodwin, who also did a stint at Disneyland. In 1957, Vineyard was sent to Brussels by the US State Department to set up a group of log-style buildings, similar to Magic Mountain's design, in the United States Pavilion for the 1958 Brussels World's Fair. Because of budget cuts, they were not included in the final pavilion design. Living up to Magic Mountain's Western theme is this story from March 17, 1958, "Kilo Henderson, star of TV series *28 Men* matched his drawing speed and skill against 'Gunman' Sam Toole, who claims the world's record at drawing a six shooter." This event at Magic Mountain was televised by Denver's KBTV. The park's marshals, along with others, played cowboys and robbers from the construction period through to the end of the 1960 season. Interestingly, Magic Mountain's marshals were officially deputized by the Jefferson County Sheriff and were armed. Native Americans were a big hit at the park's Indian Village attraction. Besides Western-themed entertainment, Magic Mountain employed actors who performed melodramas at the park's playhouse. Local teenagers entertained guests with song and dance acts (see page 79). Denver's Russell Scott, also known as "Blinky the Clown," made appearances at Magic Mountain. A Denver icon, Scott (1921–2012) hosted approximately 10,000 shows on local television from 1958 to 1998. Scott can be viewed on YouTube. A regular at the park was "Lingo the Drifter," played by Paul Lezchuk (1924–1993), also known as T.D.A. Lingo, a folk singer who was well connected to the early days of folk singer Judy Collins's career. In 1957, Lingo appeared on Groucho Marx's television quiz show *You Bet Your Life*. Lingo the Drifter is certainly worth Googling, and he can be seen wearing shorts in the crowd leaving the train station on page 59.

Shown above are excerpts of a publicity outreach letter from Magic Mountain's general manager Howard Vineyard. Driving a stagecoach from Chicago to Denver was Magic Mountain's Monty Pike's idea. The trip served two promotional purposes—first, bringing national attention to Magic Mountain and, second, promoting the upcoming Colorado "Rush to the Rockies" centennial in 1959. The 1,500-plus-mile trip west started on Saturday, June 28, 1958, at Chicago's famous Wrigley Field (shown below). This replica steel stagecoach reportedly weighed 3,900 pounds and was built by Gigmac Wagon Company of Chicago. In the front seat are driver Carlin Garrett and Toad Bricker. On the roof are Monty Pike riding shotgun and an unidentified guest. (Both, courtesy of the Allen-Pike collection.)

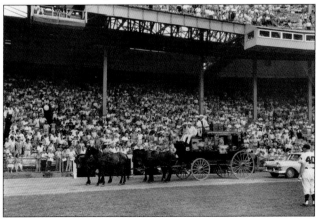

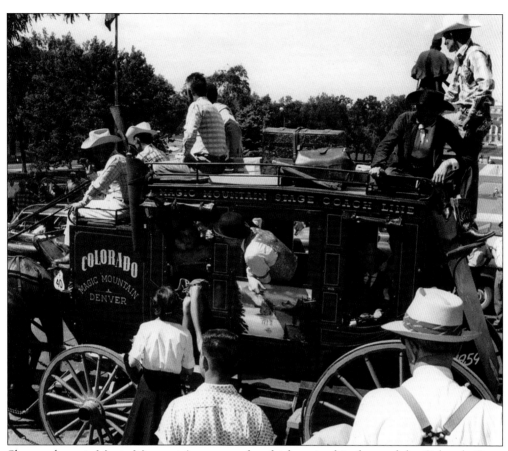

Shown above is Magic Mountain's stagecoach, which arrived in front of the Colorado State House in Denver from Chicago on Tuesday, September 9, about three weeks later than originally planned. The stagecoach was pulled by a four-horse team with Carlin Garret driving the entire trek and Toad Bricker riding shotgun. Local accounts stated, "They've used 10 horses; only one, Maverick, is still plodding along after 1,500 miles." Driving just behind the stagecoach was Monty Pike; he was in charge of logistics and publicity events along the route. Many stops, such as at state capitals, were planned, but the sight of a stagecoach traveling west caused many unplanned events to occur. Magic Mountain, Inc., purchased two stagecoaches from Gigmac Wagon Company. They also purchased one locally, shown below at the park. (Above, courtesy of the Allen-Pike collection; below, courtesy of Ron and Stephen Peck.)

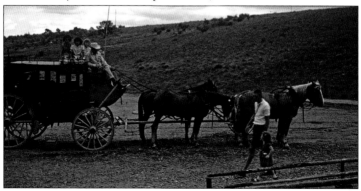

MAGIC MOUNTAIN, INC.
INTER-OFFICE COMMUNICATION
Form 10-04 Lowell Press, Denver

DATE 6/20/58

TO Monty Pike FROM Howard Vineyard

SUBJECT

In order to properly equip our investment salesmen, we need twenty (20) each
of the following pictures, in color:

1. The Birds Eye
2. Main Entrance
3. Railroad Station
4. Centennial City Street Scene
5. Cherrelyn and Shooting Gallery
6. Road Racer
7. Outer Space Line
8. Birds Eye of Storybook Lane
9. Ticket Booth and Mackinaw Boat - Fur Trapper Ride
10. Goldfields

These should be 5" x 7" in size (photos).

HOWIE

This memo (above) is a snapshot of the ongoing process from Magic Mountain's management to continue to raise funds through the sale of stock. As discussed in this chapter's summary page, Allen J. Lefferdink enters Magic Mountain's story line in late 1958 and is described by the press as a financier from Boulder. Early in 1948, his company bought the Cowie Building at 1332 Pearly Street in downtown Boulder. The building became home to Allen Enterprises and the Northwestern Mutual Life Insurance Company's district office, where Lefferdink was manager. By early 1951, Lefferdink's growing empire announced plans to construct a modern building at Fourteenth and Walnut Streets. Designed by architect James M. Hunter, this rendering (below) is the original plan, which included Lefferdink's penthouse office and a helicopter pad. The 1955 building permit was the largest investment to date for a private structure in Boulder's history. Ground breaking took place on February 15, 1955. The grand opening of Boulder's tallest skyscraper was held on February 25, 1957. (Above, courtesy of the Allen-Pike collection; below, courtesy of the Boulder Carnegie Branch Library for Local History.)

Growth of an Idea....

Pictured is a letter sent to stockholders from the new chairman of the board of Magic Mountain, Inc., Allen J. Lefferdink. (Courtesy of Beverly and Leroy Allen.)

Magic Mountain, INC.

ALLIED ENTERPRISES BUILDING
2829 EAST SECOND AVENUE
DENVER, COLORADO

Investment Division

TELEPHONE DE 3-8511

December 10, 1958

NOTICE TO STOCKHOLDERS OF MAGIC MOUNTAIN, INC.

I am pleased to inform you that I have accepted the position as Chairman of the Board of Magic Mountain, Inc. At the same time my associates and I have taken over the management control of this enterprise, we have pledged ourselves to work toward the goal of attempting to open the Park by June, 1959 in time for the Colorado Centennial Celebration.

Our attorneys are currently engaged in the preparation of a registration statement to be filed with the Federal Securities and Exchange Commission to register the common stock of Magic Mountain, Inc. The purpose of filing the registration statement is to permit the resumption of offering of Magic Mountain, Inc. securities to residents of Colorado and the extension of sales to residents of other states, in compliance with all federal and state laws and regulations. It is the intention of the Company to continue its operations vigorously, and to use the proceeds of the sale of the securities together with other funds, to complete the planned construction, to expand its operations and program, and to discharge existing indebtedness.

You may rest assured that your Company, our legal counsel and accountants engaged in this task will endeavor to complete the registration of these securities as quickly as possible. When this registration statement becomes effective, sales and stock deliveries will be resumed.

Sincerely,

Allen J. Lefferdink

Chairman of the Board

Allen J. Lefferdink, C.L.U.

A MOUNTAIN OF FUN FOR EVERYONE

SPRING . . . SUMMER . . . FALL — PLAN TO SEE THESE ATTRACTIONS DURING YOUR "RUSH TO THE ROCKIES!"

MESA VERDE NATIONAL PARK: In honor of the Centennial, Navajo rug weavers and silversmiths will be in residence. Utes or Navajos will perform ceremonial dances at night around campfires. Official opening day festivities on May 15. Mesa Verde rises sheer 2000 feet from floor of Montezuma Valley. In walls are cliff dwellings, exactly as they were when abandoned in 13th century.

NARROW-GAUGE RAILROAD EXCURSIONS: Thrill to a "Journey Into Yesterday" during daily round-trip tours of the famous Denver and Rio Grande Western Narrow-Gauge from Durango to Silverton. Centennial visitors will enjoy a special greeting on arrival in Silverton from June 1 to Sept. 30.

TRAIL RIDGE ROAD: A special welcome for Centennial year is planned with ribbon-cutting ceremonies May 30 at 12,183 feet on highest continuous highway in world. Snowplow crews will cut through snowdrifts as high as 30 feet to meet scheduled opening date.

TITAN: The mighty intercontinental ballistic missile in first public showing in world towers over Pioneer Village in Denver's Civic Center as symbol of "Rush to the Rockies" from 1859 to the Space Age. Nearby, the First Legislature of Colorado meeting place, an historic century-old log cabin.

MAGIC MOUNTAIN PARK: A Western wonderland near Denver for the young in heart, ages 4 to 90. Features the colorful history of the West in one of the nation's most intriguing amusement parks. June 15 marks official dedication of "Centennial City."

EMPERIUS MINE TOURS: Conducted tours for Centennial visitors at famous mine near Creede. View the mining facilities in the San Luis Valley.

"SOUTH PARK CITY" in FAIRPLAY: In honor of the Centennial, Fairplay re-creates an authentic mining community. See historic mementos of the hey-day of mining in Colorado . . . drugstores . . . banks . . . courthouse . . . saloons . . . pioneer homes . . . see these, and more, when this unique "town" is opened May 15. Dedication on June 13-14.

HISTORICAL DISPLAYS: In Englewood, a display of the famous Cherrelyn Horse Car . . . In Denver, tours of the U.S. Mint . . . Centennial wildlife displays at the Museum of Natural History . . . Centennial exhibits at the

State Historical Museum . . . a replica of the first Colorado Mint, Clarke and Gruber, where visitors may exchange paper dollars for silver . . . free ore samples are offered Centennial visitors at the Colorado Visitors Bureau.

HORSE RACING: Denver, Thoroughbred Racing season from July through September, Quarter Horse Racing in May and June; Brush, Quarter Horse Racing, May and June.

DOG RACING: See Centennial races at night in Loveland, Pueblo, Denver and Colorado Springs.

BASEBALL: From April 25 through September 9 in Denver for American Association.

FISHING: Centennial year season: May 16-Oct. 31.

HUNTING: Season for deer and elk begins about middle of October.

For Additional Information About "Rush to the Rockies" Events Write Colorado Centennial, P.O. Box 1959, Denver 1, Colorado

Magic Mountain, because of ongoing financial problems, missed its projected 1958 opening. A new opening date for 1959 was a fluid moving target but was designed to tie into Colorado's "Rush to the Rockies" centennial campaign. The park even renamed its re-creation of 1880s Colorado architecture—the four core blocks of buildings—to Centennial City. Colorado's centennial celebrated major gold discoveries in the Pike's Peak region.

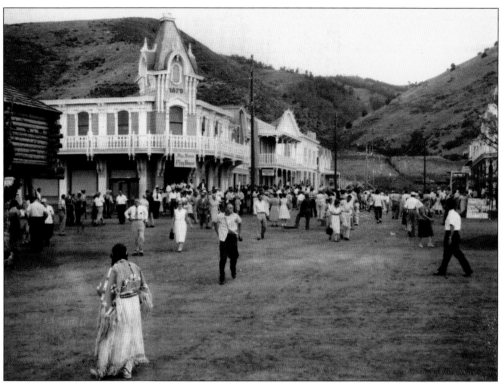

Unlike traditional amusement parks, such as Lakeside and Elitch Gardens, Magic Mountain had character actors like this Native American, pictured above in the foreground. Magic Mountain, for its short life, entertained thousands of guests, as shown in these photographs. How exciting it must have been to be a child at the height of the cowboy and Western era on television and movies to experience real-time gun fights and stagecoach and train rides. (Above, courtesy of the Joe Lunn family collection; below, courtesy of the Denver Public Library, Western Collection, Call No. 2129.)

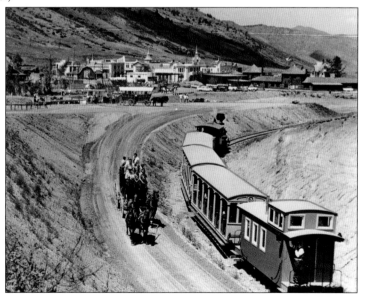

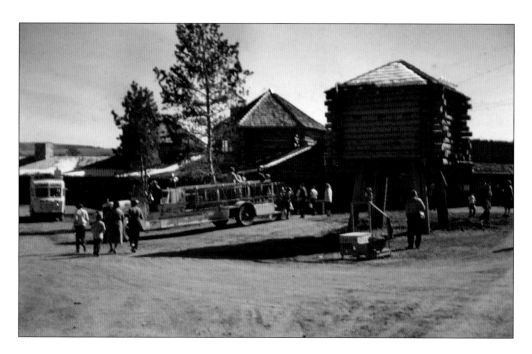

Meanwhile at the Cavalry Post is a fire engine that, according to Deputy Marshal Leroy Allen, was bought from a local volunteer fire department and placed in service at Magic Mountain. The photograph above shows the departure area for this attraction, and in photograph below, the fire engine is driving by Magic Mountain's River Ride attraction, which is under construction. (Both, courtesy of the Allen-Pike collection.)

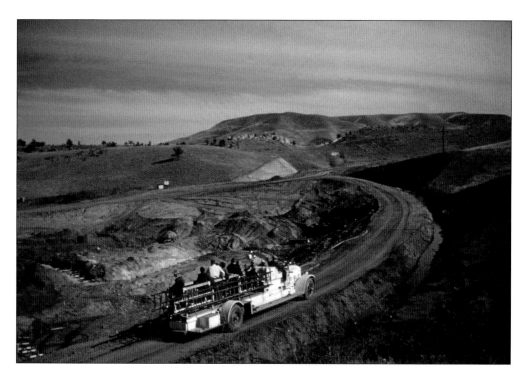

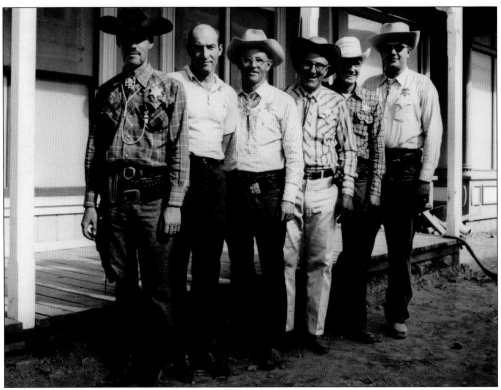

Magic Mountain had its own marshal and deputy marshals for park security. Shown in 1959 are, from left to right, Leroy Allen, George McDonald, Marshal Monty Pike, Hank Grace, Dale Picher, and Joha Shrolder. Leroy Allen, among others, wore several hats, not only for the park's security, but also for entertaining the thousands of guests with their Western gunfights they performed daily. Shown below are "Baby Doe" and Joe Lunn, who was the first deputy marshal hired by Marshal Monty Pike. *Magic Mountain* is dedicated to not only its founder, Walter F. Cobb, but also to Leroy Allen and Monty Pike, who graciously allowed this author to video record amazing details about Magic Mountain and their experiences for current and future generations. (Above, courtesy of the Allen-Pike collection; below, courtesy of the Joe Lunn family collection.)

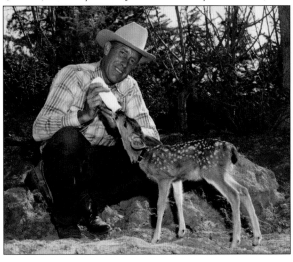

Marshal Monty Pike has a captive audience by Magic Mountain's flagpole. A portion of the Administration Building is at right. (Courtesy of the Allen-Pike collection.)

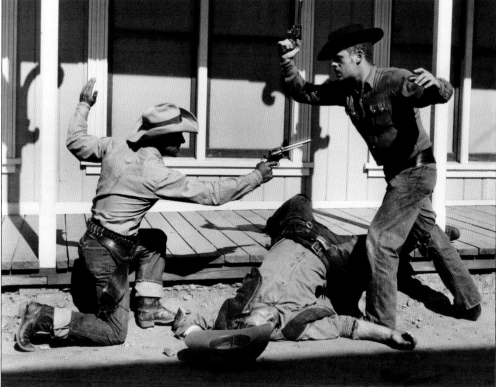

As reported in local newspapers, "Showdown drama in the real and fancied style of the old days will be provided regularly as one of the local color features that suddenly and surprisingly will be thrust upon the customers. After all, it will be the policy at Magic Mountain that nobody knows when the gunplay will break out." General manager Jim McGoodwin's son Russ, at 17 years old, narrated the bank robberies to the audience during the 1959 weekend season.

The area in the foreground was originally planned as the backstage service area for Magic Mountain's attractions. To get the park opened for weekends in 1959, this area was converted to the Road Racer site. To the right is the park's Administration Building and the Shooting Gallery is to its left. The small building at the rear of the gallery are restrooms. (Courtesy of Ron and Stephen Peck.)

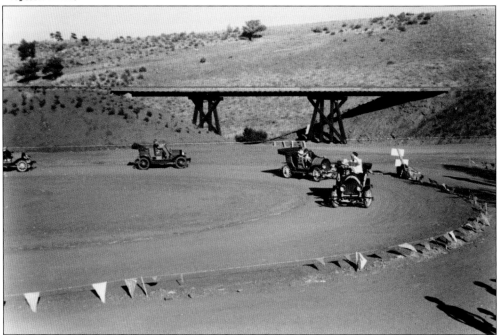

The *Rocky Mountain News* reported on Wednesday, July 29, 1959, that "a fleet of 20, arrived Tuesday in Denver via Air Express in route to Magic Mountain. The vehicles, which will operate on a 1,725 foot track, can be controlled by youngsters and have a top speed of 10 miles per hour. They're manufactured by the Arrow Development Company of Mountain View, California, which specializes in such amusement park rides." (Courtesy of the Allen-Pike collection.)

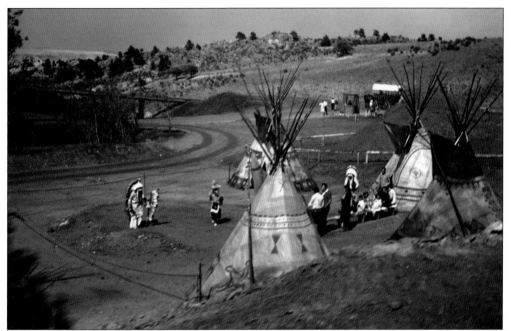

Magic Mountain's Indian Village is described in its thematic story line as follows: "Next to the River Ride is the authentic Indian Village, inhabited by Indians of many tribes. These Indians will be in their costumes and will present ceremonial dances throughout the day." (Courtesy of Ron and Stephen Peck.)

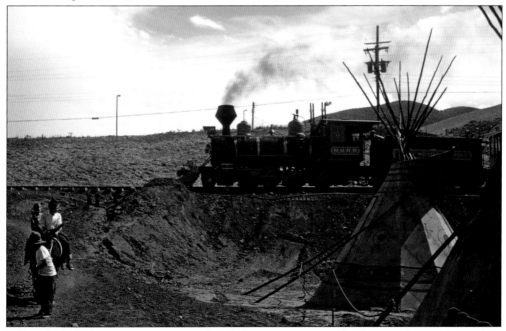

Off to the left of Magic Mountain's Indian Village is a youngster leading two burros. Depending on demand, up to eight burros could be in a train. Following the Disneyland model, each of the parks designed by Marco Engineering incorporated this attraction. (Courtesy of Ron and Stephen Peck.)

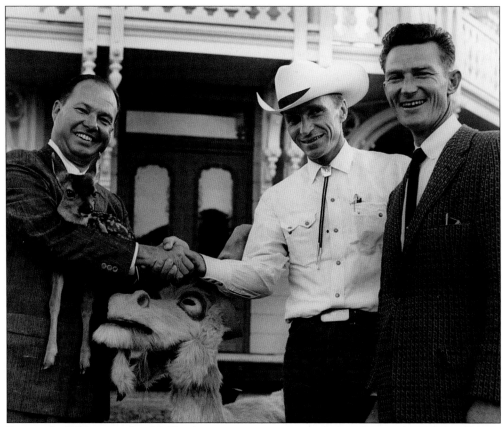

During the 1959 season, Jim McGoodwin, executive vice president and general manager of Magic Mountain, thanks Randy Steffen, center, and W.F. Murdock, right, for a 10-day-old fawn, named Baby Doe. According to a newspaper account, "The deer was flown by private plane from Gold Rush Park in Sacramento for a goodwill tour of Denver's amusement center. McGoodwin's son Scotty (9) immediately adopted Baby Doe." To McGoodwin's right is a remote controlled talking donkey, which was built in the shop. (Courtesy of Mike McGoodwin.)

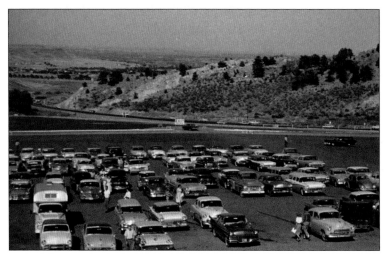

This is not an antique car meet; it is a photograph taken from Magic Mountain's train station of the parking lot in September 1959. US 40 is shown in the background along with an exit sign pointing to the park's original entrance. (Courtesy of the Allen-Pike collection.)

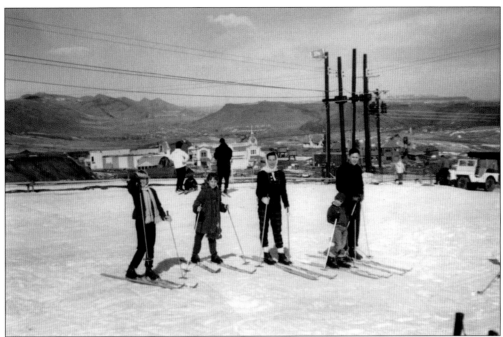

Skiing and other winter-related sports were discussed in media reports as early as October 1958. A limited version of what was planned opened January 16, 1959. Because of the park's front range location, artificial snowmaking equipment was installed, a first for Colorado. Both photographs are from the facility's second and last season 1959–1960. Local advertising stated the ski area was open daily from noon to 11:00 p.m., with floodlights for night skiers. Two tow ropes transported the skiers to the top of the slope, locally known as Jackson Hill. Another media report from February 1960 announced that Magic Mountain leased out the site for winter sports. Named Winterland, it was to cost an estimated $600,000 with a 2,000-foot sky ride, a chalet restaurant, ice skating, tobogganing, and more. Unfortunately, Winterland was never constructed. (Both, courtesy of the Joe Lunn family collection.)

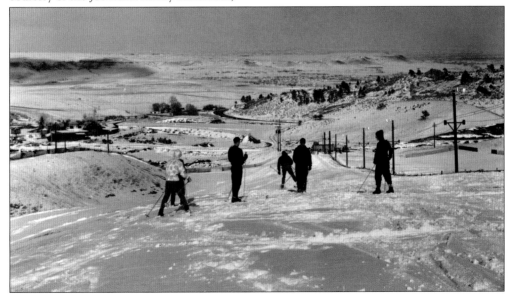

This is Magic Mountain's 1960 park flyer for the inaugural full season. In addition to completed attractions shown in this flyer is a partial list of concessionaires: the Railroad Snack Bar, Post Office and Print Shop, Trading Post, Gift Shop, Shooting Gallery, Photo Shop, Penny Arcade, Candy and Toy Store, and Plastercraft Shop, among others.

Magic Mountain's Cavalry Post served as the park's Administration Building and can be seen under construction on page 34. A trade article from January 1962 stated Magic Mountain lacked about $571,000 to complete construction. A total of 2,677,963 shares were sold for $3,349,545. However, $790,421 was taken out of stock sales for commissions. Ultimately, these shares would become worthless. (Courtesy of Ron and Stephen Peck.)

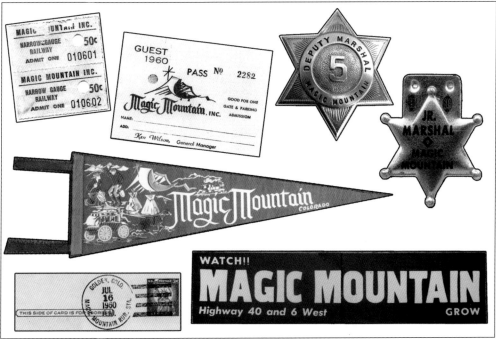

This is a rare glimpse of Magic Mountain memorabilia; courtesy of Leroy Allen are Magic Mountain Railroad tickets, 1960 guest pass, Allen's actual deputy marshal badge, a junior marshal badge, and park pennant. A time-stamped postcard is from author's collection. Magic Mountain's bumper sticker is courtesy of Rick Gardner. The junior marshal badge was a promotion by Monty Pike in November 1958 during weekend construction tours. Kids were sworn in and given instructions in the "fast draw" for their cap pistols.

Pleasure Island opened on June 22, 1959; shown above is a portion of the park's first season flyer. Freedomland's preopening flyer is also shown. Below is a photograph taken on Saturday, June 25, 1960, just a few days before Magic Mountain's opening day, Thursday, June 30, 1960. The 1960 season would be the only time Marco had all their designed parks up and running at the same time. (Below, courtesy of the Denver Public Library, Western Collection, Call No. 2129.)

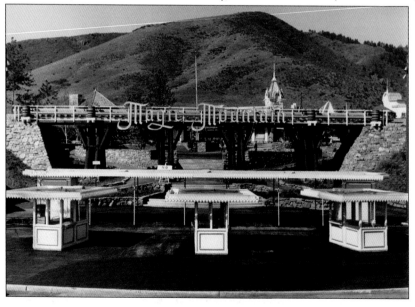

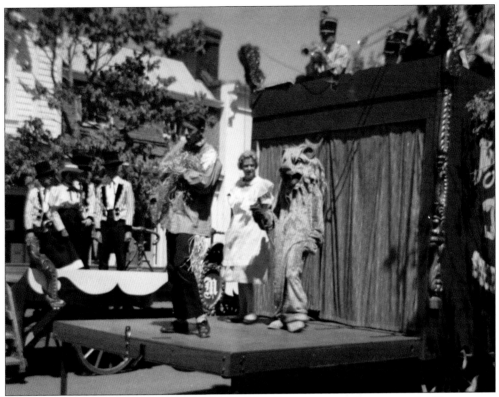

An article from 1960 states the following: "Pleasant Entertainment feature are the 12 teenagers who stage a song and dance program throughout the park. With a high stage as part of the Administration Building, the talented youngsters sing in the entrance area, then climb into two park built 'Show Wagons' and move to other areas." They are shown here performing *The Wizard of Oz*. (Courtesy of the Joe Lunn family collection.)

The Road Racer attraction, which had a temporary operation in 1959 (see page 72), was completed for the 1960 season, including the underpass-overpass track. Driving one of the 20 replica 1910 Cadillacs is Norma Jean (Lunn) Stevens, who was employed at Magic Mountain during the 1959 and 1960 seasons. Her father, Joe Lunn, was a deputy marshal and had other duties at the park. (Courtesy of the Joe Lunn family collection.)

Marco Engineering's research for existing competition in 1957 could not have foreseen two additional venues competing for Magic Mountain's share of guests available from its primary and secondary marketing area population. Two venues came online in 1960 for what would be Magic Mountain's delayed official opening season. Pete Smithe's General Store, opened in the fictional town of East Tincup, was a quarter-million-dollar Western roadside attraction, and its address was 18195 West Colfax Avenue, US 40. Reportedly, attendance was 200,000 guests in 1960 and over 300,000 guests in 1961. Celebrity Sports Center also opened in 1960 (shown below). It was located at 888 South Colorado Boulevard. Walt Disney and an "A" list of Hollywood celebrities poured over $6 million dollars into this center, with 80 bowling lanes, an Olympic swimming pool, and much more. (Below, courtesy of the Denver Public Library, Western Collection, Call No. 191.)

Five

ONE DREAM ENDS, ANOTHER BEGINS

It has been an interesting journey tracking the beginning and ending of Magic Mountain. This chapter will explore the ending of one park and the beginning of another. One thing is certain and time-stamped in history. Without Walter F. Cobb's vision for a park, created for families to enjoy, there would not have been a Heritage Square. In short, Magic Mountain laid idle after its first official season in 1960 until another visionary, Steven Arnold, rebranded the park as Heritage Square, which opened in 1971. Being the first Disney-type copycat out of the gate, Cobb gets a gold star. A number of attempts in the 1950s and 1960s never got off the drawing board. Boston's Pleasure Island went bankrupt at the end of its first season and went through three more ownerships before closing in 1969. Freedomland was the largest of all three Marco-designed parks, even bigger than the original Disneyland. This park also went bankrupt and closed after only five seasons. A fourth Marco park to be built in Miami named Discoveryland was cancelled. On April 27, 1959, Disneyland, Inc., and Walt Disney Productions filed a petition in Superior Court seeking a court order to secure testimony from C.V. Wood and the Marco Engineering Company, Inc. The petition sought to stop Wood from representing himself as Disneyland's master planner and to stop Wood and Marco Engineering from using Disneyland's trademarks or name in promoting Marco-designed theme parks. There were other issues in the petition as well. After Marco started design work on the first Six Flags park in Arlington, Texas, he merged his company with McCulloch Corporation in 1961. Wood was the master planner of McCulloch's Lake Havasu City, Arizona. It was Wood and McCulloch who, on a tip from Freedomland's William Zeckendorf Jr., bought the London Bridge and had it rebuilt at Lake Havasu. For the legal eagles, Google "Pleasure Island vs. Pepsi-Cola Metropolitan" and "Atomic Fuel Extraction Corporation vs. Slicks Estate" for an insight on just how busy Wood (1920–1992) was in his go-go years. It would take another chapter to dive into Allen J. Lefferdink's role in Magic Mountain. That is what Google is for. Also Google "Eden Palais Carousel," which was purchased and delivered from France to Magic Mountain, yet, for lack of funds, was never installed.

Guest of honor at America's finest dining places

We're extremely pleased that America's finest hotels, clubs and restaurants are joining together in a special salute to Prime and Choice Colorado Beef during National Colorado Beef Month, January, 1962. But behind this honor lie years of research and experimentation by Colorado cattlemen in raising a strain of beef which produces meat with more taste and tenderness than any you've ever eaten.

Yet the big thing about Colorado Beef is not how it came about, nor the time it took to develop this exclusive breed. The big difference can be traced to what we proudly call "the magic ingredient"...Colorado's incomparable climate. For only here,

in this high-altitude state, are steers watered on pure, glacier-fed streams, nurtured to maturity on the rich grasses of high mountain meadows then finished for market by the most scientific feeding methods known today.

The result of all this is waiting for you now at your favorite dining spot in the form of delicious steaks and roasts, prepared exactly to your liking. Why don't you join in the celebration by calling up and making "reservations for two?"

COLORADO STATE ADVERTISING AND PUBLICITY COMMITTEE, Products Division, Capitol Building, Denver, Colorado

Excerpts from a *Rocky Mountain News* story on July 3, 1961, states, "The footsteps of Tommie Tompkins, a 69 year old guard for the Colorado merchant police, are the only sounds that break the silence at the amusement park's 60 acres"; Tompkins has Magic Mountain all to himself. 'I've been up here since the first of April and go into Golden once a week for food, Tompkins said, as he sat in his comfortable quarters in the park.' The advertisement at left above came from a 1962 *New York Magazine*. The photograph was taken in October 1961 by Dutch Walla of Denver's Roach Photos. Note the cut and paste snowcapped peaks put in for the advertisement campaign. Shown below is a page from Magic Mountain's auction booklet. (Left, courtesy of Dennis Walla; below, courtesy of the Allen-Pike collection.)

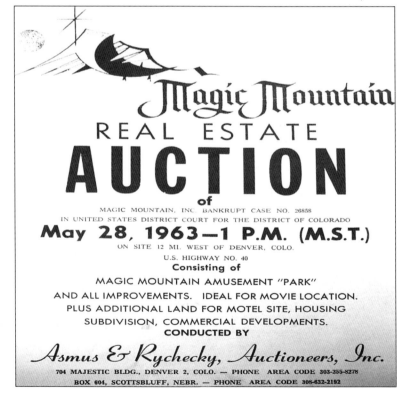

Magic Mountain

REAL ESTATE

AUCTION

of

MAGIC MOUNTAIN, INC. BANKRUPT CASE NO. 26858
IN UNITED STATES DISTRICT COURT FOR THE DISTRICT OF COLORADO

May 28, 1963—1 P.M. (M.S.T.)

ON SITE 12 MI. WEST OF DENVER, COLO.
U.S. HIGHWAY NO. 40

Consisting of

MAGIC MOUNTAIN AMUSEMENT "PARK"

AND ALL IMPROVEMENTS. IDEAL FOR MOVIE LOCATION.

PLUS ADDITIONAL LAND FOR MOTEL SITE, HOUSING

SUBDIVISION, COMMERCIAL DEVELOPMENTS.

CONDUCTED BY

Asmus & Rychecky, Auctioneers, Inc.

704 MAJESTIC BLDG., DENVER 2, COLO. — PHONE AREA CODE 303-255-8278
BOX 604, SCOTTSBLUFF, NEBR. — PHONE AREA CODE 308-632-2192

On May 8, 1963, auctioneers sold $29,000 worth of plumbing supplies, office and amusement park equipment, and electrically animated figures. *Rocky Mountain News* reported the canoe, full of "animated Indians," was formerly part of the incomplete River Ride. Six Flags Over Texas bought this gag for $2,400 to install at its River Ride attraction. This photograph was taken inside the shop building, which was to house the Creation of the World dark ride, one of many attractions designed but not constructed. (Courtesy of the Denver Public Library, Western Collection, Call No. 2129.)

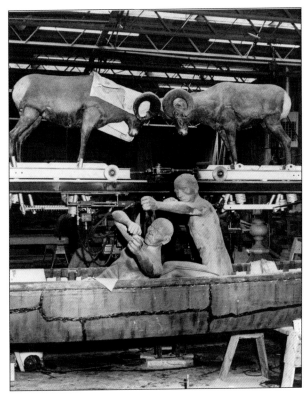

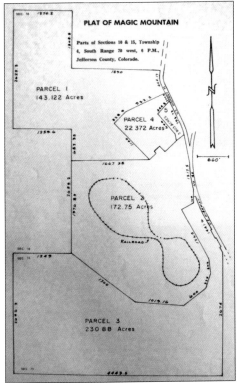

The land and improvements (the park) were auctioned off on May 28, 1963. The following bids were approved: Parcel 1, $135,000; Parcel 3, $137,700; Parcel 4, $50,500; and Parcel 5, $25,000. Benjamin Hillard Jr., chief bankruptcy referee, negotiated $360,275 for Parcel 2, up from $220,000 (the original bid). James V. McGoodwin, former general manager for Magic Mountain, represented a Phoenix, Arizona, group in purchasing Magic Mountain. The Phoenix group developed Legend City. (Courtesy of the Allen-Pike collection.)

The Colorado Building (see page 66) was constructed by Magic Mountain's Allen J. Lefferdink. Thanks to the current owner, Bill Reynolds, there is an outstanding display in the lower lobby documenting the building's history. A rolling slideshow of historical photographs can be viewed at street level. On November 6, 2014, the Boulder City Council voted unanimously to designate the 100-foot Colorado Building as a local landmark. (Photograph by Roy Johnson.)

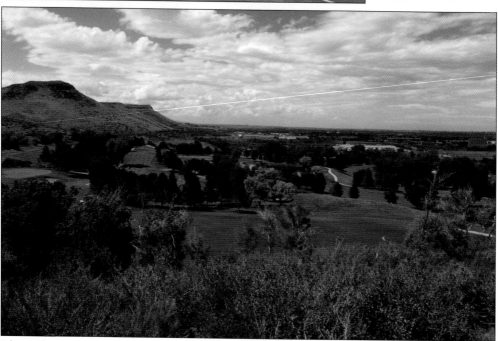

This is the original 1957 location of Magic Mountain. In the mid-1960s, Coors Brewery developed the Rolling Hills Country Club where Magic Mountain was to be built. Applewood Golf Course occupies the former Rolling Hills course on land owned by Molson Coors as of the writing of this book. Both courses are located on West Thirty-Second Avenue in Golden.

Known as the Bailey Mansion, this 1889 Queen Anne–style building at 1600 Ogden Street, Denver, was the headquarters for Magic Mountain's design team (see page 20). A local newspaper article reports, "Nearly a dozen rooms are given over to displays, miniature working models and colored pictures that depict the new park." Salesmen conducted tours of the sales and engineering offices to potential investors in Magic Mountain's stock. This beautiful mansion is currently home to the Sawaya Law Firm.

The Café Prague at 209 Bear Creek Avenue, Morrison, Colorado, was once home to the Special Effects Company, headed by Winfield Hubbard. This building has been meticulously restored by Bear Creek Development Corporation of Morrison. Hubbard was Magic Mountain's special effects chief and made Morrison his home after 35 years with Metro-Goldwyn-Mayer. Hubbard's company built special effects for parks throughout the country. He passed away in 1976 at the age of 82.

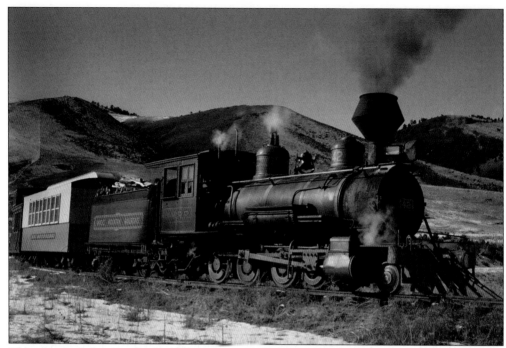

This photograph was taken on January 24, 1966, during the filming of scenes for a Western television pilot called *Stagecoach to Seven*. Besides the train, there was also a stagecoach pulled by six horses. Note the excursion car, apparently winterized for storage. Most likely, this was the first and last time No. 42 was actually used other than as a static exhibit since Magic Mountain closed on Labor Day 1960. (Courtesy of Western Rail Images.)

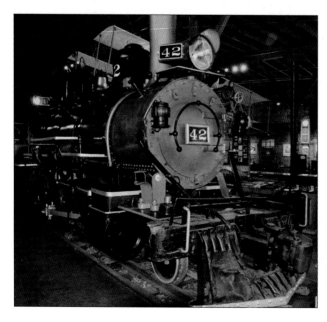

Ed Gerlitz, under lease from Heritage Square's Woodmoor Corporation, built and operated a two-foot-gauge railroad attraction, which replaced Magic Mountain's three-foot track. According to railroad historian Bill Robie, "In 1981, No. 42 was acquired by Ed Gerlitz from Woodmoor Corporation, who subsequently traded it to Charles Bradshaw at the Durango & Silverton Narrow Gauge Railroad, in return for six "charter runs" on the Durango to Silverton line. No. 42 currently remains at Durango in the roundhouse as a non-operating display." (Photograph by Yvonne Lashmett.)

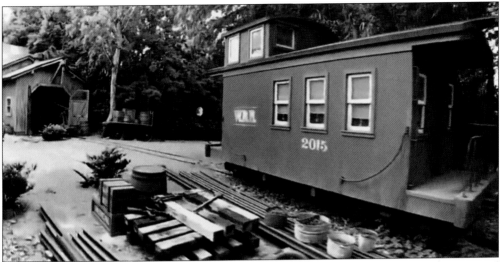

Magic Mountain Railroad's equipment returned to Heritage Square in 1971. Two cars were used for dining and the other for concessions. The caboose was used as a cocktail lounge. Ed Gerlitz acquired the c. 1878 caboose from Woodmoor Corporation and, subsequently, sold it to Tokyo Disneyland for the Western River Railroad's static exhibit, shown above. Reportedly, this is the oldest piece of railroad equipment at any of the Disney parks. (Courtesy of LMG Vids.)

According to Bill Robie's research, in addition to purchasing No. 42 and the caboose, Ed Gerlitz also acquired Magic Mountain's three excursion cars from Woodmoor Corporation. Gerlitz then sold the three cars to the owners of the Georgetown Loop. In 2004, two of these cars were relocated to the Colorado Railway Museum in Golden. This photograph of reconstructed No. 15 was taken on April 11, 2011.

The photograph above was taken on October 11, 2010, of the second car from the Georgetown Loop. On a subsequent trip to Golden, the photograph below, taken on April 11, 2011, shows the same car. According to Bill Robie, "Just weeks earlier, the car was dismantled and the steel-frame undercarriage converted to use as a make-shift flatcar." Bill Robie is shown at left. Robie is a current trustee and past president of the Colorado Railway Museum.

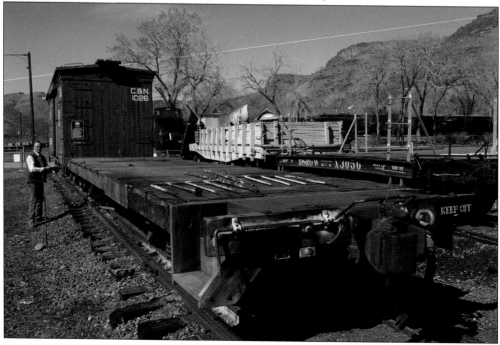

On July 8, 2011, this author and Bill Robie accessed the storage shed facility with permission from Heritage Square's previous owner, LaFarge Corporation. The view in the photograph above is looking north toward the dogbone cut. The building and the bump-out shop area can be seen under construction on page 56. The view in the photograph below is looking south inside the tunnel, which is also referred to as the snow shed. Note the asbestos panels above both the maintenance and travel track routes to catch the sparks from the engine's smokestack. To the left at the south end was the shop and drop pit area for maintenance. Large funnel-type flues were installed through the roof over the drop pit and main track to line up with the idling engine's smokestack.

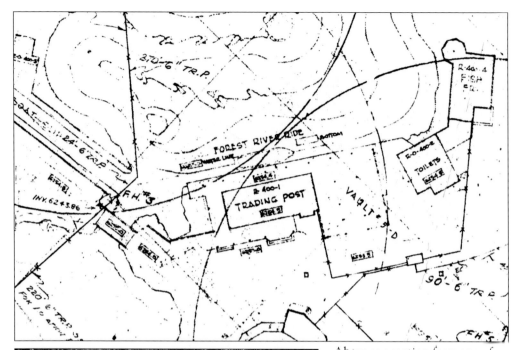

Above is a section from one of Magic Mountain's blueprints, titled Utility Plans–Sheet M2. Shown is part of the River Ride area, the Trading Post, and queue line, which can be seen under construction on page 44. Note the concrete retaining wall in front of the Trading Post with the log posts supporting the queue line roof system. This author located the supports for those posts, which are attached to concrete piers behind the buried retaining wall, as shown in the photograph at left, taken on July 10, 2011. To their left is the pad for the Trading Post, which burned down in 2010. To their right is the miniature golf course, which sits on top of the River Ride attraction, which unfortunately was never completed. This is where the Mackinaw boats would have been loaded and off-loaded, similar to Disneyland's Jungle Cruise (see page 15). (Above, courtesy of Terry Raney.)

This is an original building from Magic Mountain and is shown on the blueprint at the top of page 90. The tent, with yellow and green stripes, is sitting where the Trading Post was, using the same floor. The blockhouses and Administration Building at the park's entrance area have been removed, leaving just the front of the original Shooting Gallery building with the only remaining log construction. The Fish Fry restaurant, also shown on the blueprint, was never constructed (see its rendering on page 32).

Shown here with Joe Lunn in early 1961 is Magic Mountain's Baby Doe all grown up (see pages 70 and 74). Lunn, former deputy marshal, joined Magic Mountain's Winfred Hubbard and his Special Effects Company, where he worked on projects from Six Flags Over Texas to Cedar Point in Sadusky, Ohio. Eventually, Lunn started his own animation business creating effects for local institutions, such as Elitch Gardens and the Denver Wax Museum. (Courtesy of the Joe Lunn family collection.)

In 1964, Beverly and Leroy Allen took their two young daughters to see where daddy used to work as a deputy marshal and cowboy actor. Standing in front of Magic Mountain's flagpole are the sisters, two-year-old Linda and five-year-old Cheryl. Like Disneyland, Magic Mountain also had a plaque. It states, "Dedicated to the pioneers of the West–Magic Mountain." (Courtesy of Beverly and Leroy Allen.)

A new chapter in Magic Mountain's history was born in 1971 with the opening of Heritage Square. With the rebranding of Magic Mountain to an "Artisan's Marketplace"; the rebirth of the railroad, live theater, and evolving recreational ventures; and ownership changes, it became apparent there needs to be a book. This author is currently in the research phase for *Heritage Square*. This photograph was taken July 8, 2011.

Magic Mountain designers placed the entrance to the park so guests would enter below its narrow-gauge railroad, similar to Disneyland. Since 1958, when potential investors looking to own a piece of Colorado's very own Disneyland walked under this bridge, hundreds and thousands have followed. Young and old, brides and grooms, and as some have suggested, even a few spirits have climbed these steps.

Theater has evolved since free melodramas were performed for weekend guests when the park was under construction. The year 1971 brought Bill Oakley's Productions, which, shortly after, opened The Music Hall; in 1988, it was reopened by T.J. Mullen. By December 31, 2013, sadly, The Music Hall stage went dark. In early 2015, many of The Music Hall performers, including Mullen, came to Golden's Miner's Alley to bring back the popular children's shows. This photograph was taken October 21, 2010.

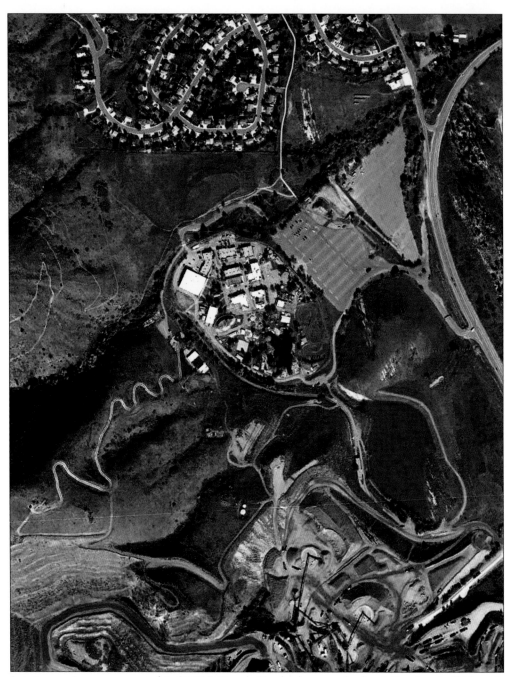

It is interesting to compare this © 2015 Google Earth photograph, dated October 6, 2014, with Colorado Aerial Photo Service images on pages 19, 50, and 51 and compare the development of this area since 1957. This Google Earth map shows a portion of the mining operation and Heritage Square, currently owned by Martin Marietta Materials. The alpine slide is also shown on the left. The original entrance to Magic Mountain was where US 40 and State Highway 93 intersected, seen at upper right. The pond in Heritage Square and a large reservoir were both constructed for Magic Mountain. (Courtesy of © 2015 Google Earth.)

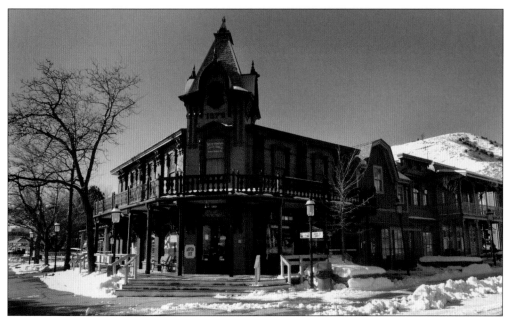

On February 12, 2015, Heritage Square's current owners, Martin Marietta Materials, issued a press release to the Denver-area media that Heritage Square, with a few exceptions, would be closing December 31, 2015. The Victorian event center and the amusement park were the exceptions. This page is dedicated to not only the original Magic Mountain vendors but to the hundreds of small businesses over the last 45 seasons that have made up the heart and soul of Heritage Square. Both of these photographs were taken on March 6, 2015. Some of Heritage Square's businesses have operated for decades, such as Professor Goodbellows, Wings of Eagles, Notz Landing, Spider Mansion, The Alpine Slide, and so many more. It is impossible to predict this site's future, but this author wishes Aspen Lee Gifts owner Chung Park (right), who has spent 20 seasons at Heritage Square, and fellow businesses the best. Please visit www.friendsofpleasureisland. org for additional information.

DISCOVER THOUSANDS OF LOCAL HISTORY BOOKS FEATURING MILLIONS OF VINTAGE IMAGES

Arcadia Publishing, the leading local history publisher in the United States, is committed to making history accessible and meaningful through publishing books that celebrate and preserve the heritage of America's people and places.

Find more books like this at
www.arcadiapublishing.com

Search for your hometown history, your old stomping grounds, and even your favorite sports team.

Consistent with our mission to preserve history on a local level, this book was printed in South Carolina on American-made paper and manufactured entirely in the United States. Products carrying the accredited Forest Stewardship Council (FSC) label are printed on 100 percent FSC-certified paper.

MADE IN THE USA